[Background Conversation]

FRESH DIALOGUE FIVE

New Voices in Graphic Design

PRINCETON ARCHITECTURAL PRESS

AMERICAN INSTITUTE OF GRAPHIC ARTS NEW YORK CHAPTER

NEW YORK, 2005

PUBLISHED BY
PRINCETON ARCHITECTURAL PRESS
37 EAST SEVENTH STREET
NEW YORK, NEW YORK 10003

FOR A FREE CATALOGUE OF BOOKS, CALL 1.800.722.6657.
VISIT OUR WEBSITE AT WWW.PAPRESS.COM.

EDITING: NICOLA BEDNAREK
DESIGN: DEB WOOD

SPECIAL THANKS TO: NETTIE ALJIAN, JANET BEHNING,
MEGAN CAREY, PENNY (YUEN PIK) CHU, RUSSELL
FERNANDEZ, JAN HAUX, CLARE JACOBSON, JOHN KING, MARK
LAMSTER, NANCY EKLUND LATER, LINDA LEE, KATHARINE
MYERS, LAUREN NELSON, JANE SHEINMAN, SCOTT TENNENT,
JENNIFER THOMPSON, AND JOSEPH WESTON OF PRINCETON
ARCHITECTURAL PRESS —KEVIN C. LIPPERT, PUBLISHER

LIBRARY OF CONGRESS CATALOGING-IN-PUBLICATION DATA
IS AVAILABLE FROM THE PUBLISHER

contributors

RODRIGO CORRAL

ALAN DYE

AGNIESZKA GASPARSKA

OMNIVORE (ALICE CHUNG AND KAREN HSU)

moderator

CHIP KIDD

time

26 MAY 2004

location

FASHION INSTITUTE OF TECHNOLOGY,
NEW YORK CITY

contents

FOREWORD

Fresh air, fresh fish, fresh brewed, fresh flowers, fresh toast, freshly squeezed, and of course... Fresh Dialogue. AIGA/NY's annual panel discussion with young, talented designers has introduced many stars to the design community, showcasing works by Jonathan Hoeffler, Tibor Kalman, Jennifer Morla, and Stefan Sagmeister, among many others.

This year we chose our participants from a wide range of disciplines and experience, looking for designers who, no matter how experienced they are or what they specialize in, are producing work that is current and powerful, are constantly engaged with the culture at large, and are always searching for fresh solutions.

We ultimately chose five talented people from the disparate worlds of fashion, publishing, web, advertising, and art—Alice Chung, Rodrigo Corral, Alan Dye, Agnieszka Gasparska, and Karen Hsu, . With the help of the estimable Chip Kidd, who served as an energetic moderator, our group participated in a dialogue about their work and ideas. The audience was treated to a wonderful array of work, including the vibrant new Times Square identity, a daringly sophisticated Whitney Biennial catalogue, book jackets without words, and a dynamic website for Fischerspooner. Kidd challenged the panel to reveal everything—from their secrets to staying fresh and their influences in design to some of the strangest projects they've ever worked on. This book is a documentation of an inspiring evening of design and discussion. Enjoy! Stay Fresh!

CHRIS DIXON AND JOHN FULBROOK III
Fresh Dialogue Chairs
2004 Board Members, AIGA/NY

[*The spotlight centers on the left part of the stage where a podium is set up. A few feet to the right the five panelists sit behind a desk, with laptop computers in front of them. In the background a projection screen is visible.*]

[*Enter Chip Kidd.*]

CHIP KIDD. Hello everyone and welcome to Fresh Dialogue. Our panelists tonight are Alice Chung and Karen Hsu, Agnieszka Gasparska, Alan Dye, and Rodrigo Corral.

Alice Chung and Karen Hsu are the founders of Omnivore, a small but prolific design studio with a voracious appetite. They have recently collaborated with the Whitney Museum of American Art; the Venice Biennale for Architecture, with Asymptote; the Institute of Contemporary Art, Philadelphia; the Contemporary Art Museum, St. Louis; the Philadelphia Museum of Art; the American Museum of Natural History; the Bronx Museum of the Arts; White Columns; Deitch Projects; Creative Time; Princeton University School of Architecture; Harvard University Graduate School of Design; Sigerson Morrison; and Human Rights in China (HRIC); among others.

Omnivore projects have been featured in *Metropolis* magazine, *Print* magazine, *WWD Beauty Biz* magazine, *306090*, and *Step* magazine. They also received a merit award from the Art Directors Club. Alice Chung studied at the Rhode Island School of Design, where she received a BFA and a BGD. After school, she worked at 2x4 in New York for four years. Chung teaches undergraduate typography at Yale University School of Art, where she has also been a visiting critic. Karen Hsu received a BFA in graphic design from Oregon State University and an MFA in graphic design from Yale University School of Art. In New York, Hsu worked at Number Seventeen and 2x4. She was one of *Print* magazine's new visual artists for 2003, with past 2x4 projects in the Cooper-Hewitt National Design Museum 2003 Triennial Exhibition. She is also a critic at the Yale University School of Art graduate graphic design program.

Interactive media, broadcast, print, and fashion designer Agnieszka Gasparska is the founder of the Brooklyn-based design studio Kiss Me I'm Polish. While her interactive design work has received recognition from publications such as *Time*, *Step*, and *Print*, Gasparska's practice hopes to extend far beyond the realm of your typical web designer. She thrives on maintaining variety in her practice, embracing design as a discipline that embodies an infinite number of media and formats and drawing inspiration from everything from surfing and dogs to her love for costume and interior design.

Twenty-seven-year-old Gasparska received her BFA from the Cooper Union School of Art in 1999. Before establishing her own practice, she spent five years as an art director at New York City's Funny Garbage. Clients have included Bloomberg, LEGO, Knoll, the American Museum of Natural History, the Experience Music Project, and Fischerspooner.

Alan Dye has been design director for Kate Spade and Jack Spade since February

2004. Kate Spade started as a handbag company in 1993 and has quickly grown to include a wide variety of categories from shoes to a home collection. Previously, Dye was design director and partner at Ogilvy & Mather's brand integration group, BIG, where he worked with Motorola, Miller Brewing Company, Levis, and Times Square NYC. Prior to joining Ogilvy, Dye spent four years at Landor Associates' New York office doing brand and corporate identity work for clients including Delta Airlines, Pepsi Cola, and Mothers Against Drunk Driving (MADD). Dye's work has been recognized by several design shows and publications including *Communication Arts*, *Print ID*, *365: The AIGA Year in Design*, and *Graphis*. Last year, *Print* magazine selected him as one of their new visual artists in the annual Twenty Under Thirty issue. Dye is an avid painter, illustrator, and basketball player.

Rodrigo Corral is a former student of mine at the School of Visual Arts. He has designed many ingenious book jackets for Farrar, Straus and Giroux (FSG), Doubleday, and independently for Rodrigo Corral Design Inc. His work has been featured in *Abitare*, the *New York Times*, and *Print* magazine.

We don't really have a theme tonight, but our panelists do all share one aspect in common that has shaped their work. Each of them started out working for a design-based business of note. Alan was at Ogilvy;

Rodrigo at FSG; Alice at 2x4; Karen at Number Seventeen and 2x4; and Agnieszka at Funny Garbage. And then, after some time, they each started their own businesses or joined another firm. Tonight they will show us some of their early and more recent work and share insights on their experiences, ideas, and thoughts.

FRESH DIALOGUE FIVE

Where We Were

RODRIGO CORRAL. After graduating from the School
of Visual Arts, I started working as a designer at
FSG, a literary publishing house that puts the
emphasis on the content of the book, as opposed to
marketing and branding. During my first few months
there I mostly worked on books that were being
repackaged as paperbacks, reusing the art from the
hardcover. Since the budgets for these books were so
low, I mainly tried to establish a grid and be creative
with type.

 The first cover I designed at FSG was not
particularly fresh, but I did have to start somewhere.
A Cool Million and The Dream Life of Balso Snell, by
Nathanael West, is a book of two short stories that
satirize the American Dream. One of them is about a
man who climbs into the Trojan Horse, which was
the inspiration for the cover illustration by Ellen
Ruskin. The hardcover edition used the same illustra-
tion, with a different placement and type treatment.

 In *The Death of Satan*, a nonfiction book,
Andrew Delbanco argues that Americans have lost
their fear of evil and explains why this attitude is bad
for society. While I still did not have a reasonable
budget to work with, I was able to use new art for
this cover, if only spot art.

 The same illustrator, Donna Mehalko, worked
on the next book, *Hunger*, by Knut Hamsun, which
tells the story of a young writer in Norway who's
living on the streets, battling starvation, and trying
to stay sane.

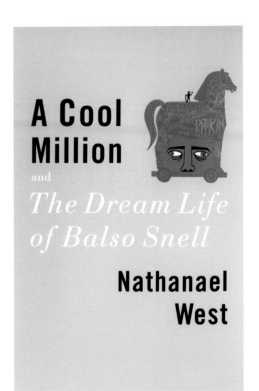

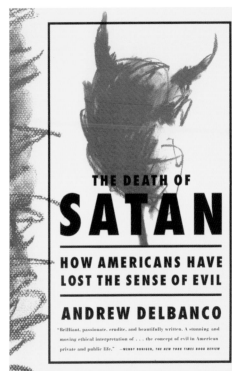

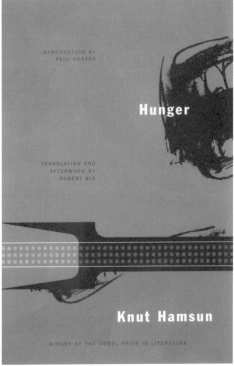

A year later, I started to work with Susan Mitchell, art director at FSG, designing hardcover jackets with a budget to hire professional (i.e. expensive) photographers. I was very excited about the first cover for which I hired someone and was convinced that the publisher was going to love it. *The Life of Insects*, by Victor Pelevin, is a novel whose characters are transformed from insects into men and back again, similar to Kafka's *Metamorphosis*. I had the photographer shoot a wind-up toy called "the critter," which I had bought at the Guggenheim Museum's gift shop. It looked like an insect, and I thought it would work well with the title. But when I showed the cover to the editors and publisher, they said, "No, this is too cold. It's too European." As I had no budget left, I asked a friend of mine, Frederick Schmitt, who likes to shoot in his free time, to take this picture of a girl wearing huge sunglasses.

The experience of being able to find people like myself who are just interested in doing the work and not too concerned about the money was very valuable to me. At the time I was still feeling a bit insecure about approaching someone who was established and saying, "Here, this is my idea, shoot this," so working with somebody who was more on my level turned out to be a nice fit. Besides, hiring a professional does not automatically make a design work. I wanted to use "the critter" because I thought it was cool, but when it was rejected, I realized that it wasn't the photography that had been turned down but my idea. And when I rethought the design, the result was much better.

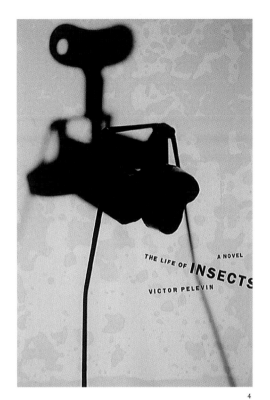

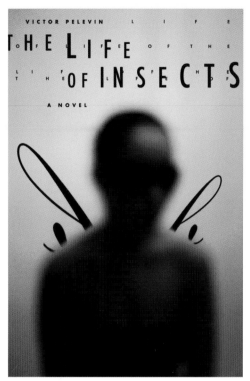

These next few jackets, *Mysticism for Beginners,*
On the Rez, and *Paris Trance*, were all shot with a
modest budget, about three hundred dollars each.

KIDD. Three hundred bucks?

CORRAL. Yeah...so sweet.

[*Laughter*]

At this point, I was in love with the concept of
avoiding stock photography. Using stock images felt
too easy; besides, I didn't like the idea of walking into
a bookstore and on every second cover seeing an
image that I knew—"That's from Photonica, that's
Corbis, that's Getty." So instead I hired friends or
took the pictures myself.

My first freelance cover was also the first for
which I did my own photography. Timothy Hsu,
who had studied with me at the School of Visual
Arts and was now the art director at W. W. Norton,
hired me to work on *Survivor*, by Chuck Palahniuk.
Survivor is about a man who is the last living mem-
ber of a religious cult. Everyone else in the group has
committed suicide, and because the narrator is the
last one alive, he becomes famous. The story is told
through the flight recorder of a plane the narrator has
hijacked. The image on the cover is a close-up of a
face, and the type reads from top to bottom to show
how everything in the book goes downhill.

KIDD. Was that your first jacket for Chuck Palahniuk?

CORRAL. Yes.

KIDD. But this was before the *Fight Club* movie came
out and Palahniuk became famous?

CORRAL. Yes, this was only Palahniuk's second book.
The first one was *Fight Club*, but the movie had not
come out yet.

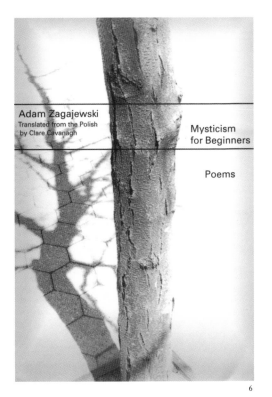

Adam Zagajewski
Translated from the Polish
by Clare Cavanagh

Mysticism
for Beginners

Poems

6

AUTHOR OF *Great Plains*

On the

REZ

IAN FRAZIER

7

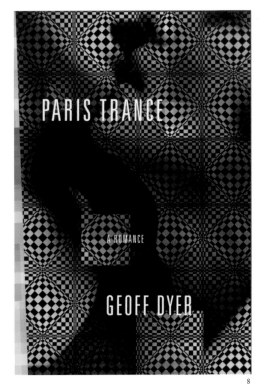

PARIS TRANCE

A ROMANCE

GEOFF DYER

8

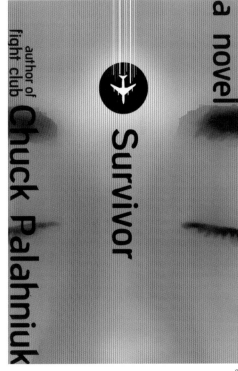

a novel

author of
fight club

Chuck Palahniuk

Survivor

9

At that time I had been at FSG for five years, so I was ready to move on. Grove/Atlantic, another publisher of fiction, offered me the position of art director, and I decided to jump to it. Unfortunately, this did not last for very long; I think I was there for about five to six months at best. These were the two pieces that I got out of working there, the hardcover catalogue cover and the paperback catalogue cover.

11

10

[*Laughter*]

KIDD. Why did you leave Grove/Atlantic?

CORRAL. Well, let's just say this: if you're working, do you want someone to come and sit at your machine and start doing your work for you?

KIDD. Ah, that's tough.

CORRAL. Throughout this time, I also had the chance
to work on some Op-Ed pieces for the *New York*
Times with art directors Nicholas Blechman,
Christoph Niemann, and Peter Buchanan-Smith.
Nicholas Blechman sent me an article that stated that
U.S. media was losing respect among the world's
media groups. To visualize the subject I used an
image of a tape recorder with all the tape pulled out.

Designing these pieces, I realized that I enjoyed
creating images and focusing on ideas that were
image-driven. The Op-Ed designs appear together
with a paragraph or two of text, and the image has to
sum up the text, state an opinion, or give an idea—all
without using type. This kind of work appealed to
me, and I started to use the same approach in my
cover designs as well. I begin the design process by
reading the text, looking for the moment that defines
the book, for the message that the author wants to
send out, and then try to convey this message
through a design solution.

[*Applause*]

Recovering Japan's Wartime Past — and Ours

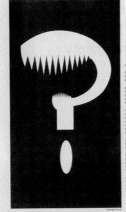

By Steven C. Clemons

Reparations and the anniversary of a peace treaty.

Classes Of Last Resort

By Floyd H. Flake

Rodrigo Corral

The statistics don't tell the story of charter schools.

The United States Olympic basketball team's gold medal hopes would be significantly diminished if it were forced to shoot at a rim that was 11 feet high rather than 10 feet like its competition's. The gold might well end up in Lithuania — but would this mean that the winning team from Vilnius was better on the court than the Americans? Of course not. Rather, it would establish that in an unfair competitive environment, people and institutions with real advantages will normally win.

This is precisely the standard that critics apply in comparing public education's two main forms: traditional schools and charter schools. The most recent example is a number-crunching exercise of federal school statistics by the largest teachers' union, the American Federation of Teachers.

While the analysis showed charter schools lagging somewhat behind traditional schools in reading and math, it did not contain any explanation of the structural inequities between the two that leave charter schools at a permanent disadvantage. Given time and a level playing

The Watchdog, Now Grown Rabid

By Jerry Nachman

An unsourced rumor shows the press at its worst.

Foreign Affairs
THOMAS L. FRIEDMAN

The Big-Ship Economy

By Gustavo Gorriti

Where Journalists Still Get Respect

Rodrigo Corral

The U.S. media's example no longer inspires.

In Latin America, the press is popular — and in peril.

Is America a supertanker, or the Titanic?

ALAN DYE. I originally studied illustration and commu-
nication design at Syracuse University. After gradua-
tion I moved to New York and accepted a position at
the design agency Landor, which I considered a
pseudo-grad-school-type situation. It was a great
place to be as a young designer, giving me the chance
to learn the ropes and get a better understanding of
what it's like to work at a large, corporate branding
firm. I was able to work with a wide range of clients
in a variety of media—including everything from an
identity for Mothers Against Drunk Driving
(MADD) to packaging for Molson beer. The MADD
identity evokes the feeling of just how shattered lives
can become due to drunk driving.

17
18
19
20

16

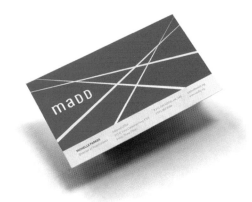

16

17

18

19

20

22 For Molson, I designed a new line of packaging that established Molson as the leading Canadian beer currently sold in the U.S. Having grown up in Buffalo, a big Molson-drinking town just across the border from Canada, this was a great project for me. All of my friends and family got a huge kick out of it, and they finally had a better idea of what I did for a living.

21 One of my last assignments at Landor was this packaging for Yoo-hoo. I kind of knew it was time to go when I was designing limited-edition packaging for artificial chocolate milk.

[*Laughter*]

My time at Landor was well spent, but as a young designer I knew that in order to stay energized, I needed a change. So in the fall of 2000, I accepted a position at Ogilvy & Mather's Brand Integration Group, better known as BIG. BIG is essentially Ogilvy's strategic design team, which allows the agency to work with its clients in a much more holistic way than other agencies. In other words, it allows for a great consistency between advertising and design.

KIDD. How many people are there at BIG?

DYE. Including the strategy and account people, about twenty. There were maybe ten to twelve designers, so our department was quite small. This structure allowed us to remain as agile as a small studio and still work for large clients. Brian Collins, the executive creative director at Ogilvy, had gathered a fabulous group of people, and I was eager to work with and learn from them. I was also interested in seeing how a huge advertising agency like Ogilvy operated.

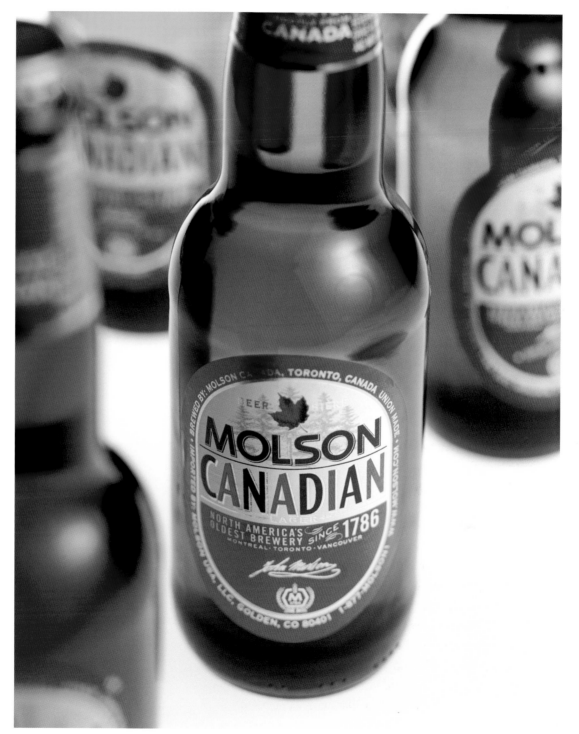

BIG allowed me to work with brands on a much larger scale than I had at Landor. We always looked at the entire picture, putting the focus on how a brand is experienced as opposed to simply designing a new logo or a new package. A good example of this kind of thinking was the work we did for Motorola, which was essentially a complete redesign of the brand.

23

For years, Motorola led in the marketplace because of its superior engineering and its ability to create a smaller phone. But now that cell phones had gotten as small as they were going to get, the firm knew that it needed to leverage design and advertising in a much more effective and consistent way than it had in the past. Motorola originally came to us looking for a new logo, but we realized that the logo wasn't actually the problem. The logo was in fact pretty great; it was almost everything surrounding their logo—the other pieces of communication such as packaging or advertising—that needed an overhaul. We gave the company a new worldwide color palette, redesigned their packaging and advertising, and rethought how they shot photography—we basically started from scratch, all in an effort to give Motorola a new voice and personality. Overall, we wanted to appeal to a younger, more fashion-oriented consumer, based on the fact that the cell phone has become as much of an accessory as a necessity. Eventually, all of these pieces came together at a trade show in Germany, where we launched the new look and feel of the brand.

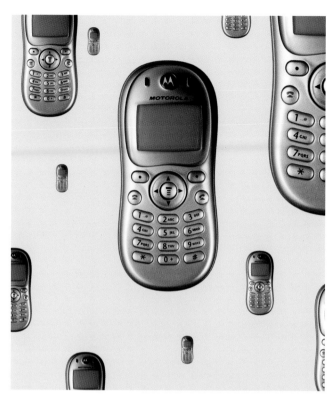

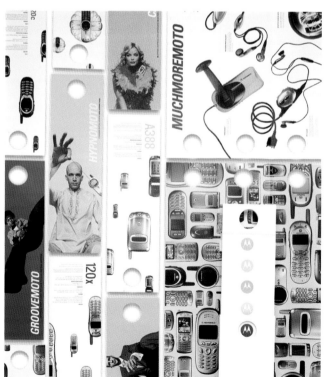

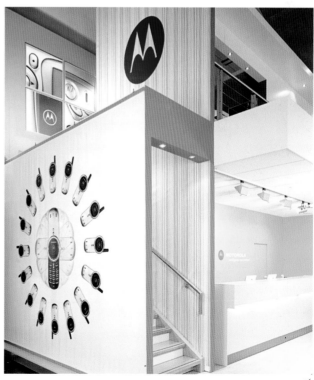

Another good example of the projects we worked on at BIG is the corporate identity we developed for the Miller Brewing Company. The people at Miller liked the work we had done for Motorola, so they wanted us to do the same thing for them— basically recreate their brand from the ground up. But when we started looking at the company and researching their archives, we found that they already had a rich visual history and didn't need to create something new just for the sake of newness. Instead, we convinced them to reclaim their history and use some of their old graphics. We designed various mood boards in order to show how the vibrant, beautiful symbology that was there from the firm's beginnings could be reused to emphasize Miller's focus on craft and heritage. We began this process by redrawing the iconic Miller script with the help of typographer James Montalbano and creating a signature corporate seal. For the company's corporate type family, we chose a group of typefaces that not only reflected its heritage but were also developed around the same time as the firm's founding.

MILLER BREWING CO
SINCE *1855*
MILWAUKEE, WIS. USA

27

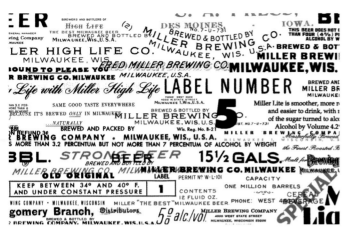

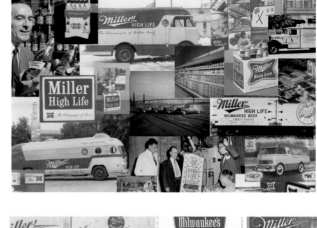

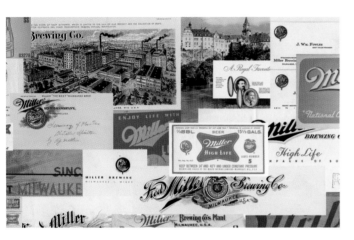

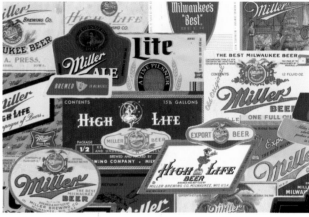

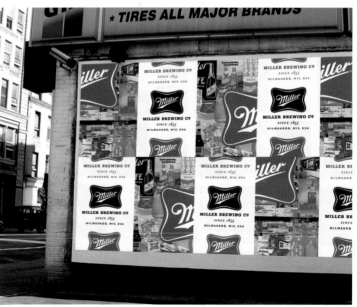

29
30

The first project on which we tried out this approach was a redesign of the Miller High Life packaging. Essentially, our goal here was not to rely on the computer but to craft a label the same way that it might have been crafted at the turn of the century, when High Life was born. We also spent a considerable amount of time studying packaging from postwar America, feeling that the High Life brand was epitomized by this era. We redrew the "High Life Girl," making her look like the kind of woman that would have been painted on the side of an airplane during World War II. Overall, I think that we were successful in changing the company's mindset from one that seeks constant transformation to one that takes advantage of its proud past to differentiate itself in the future.

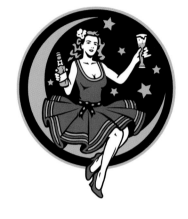

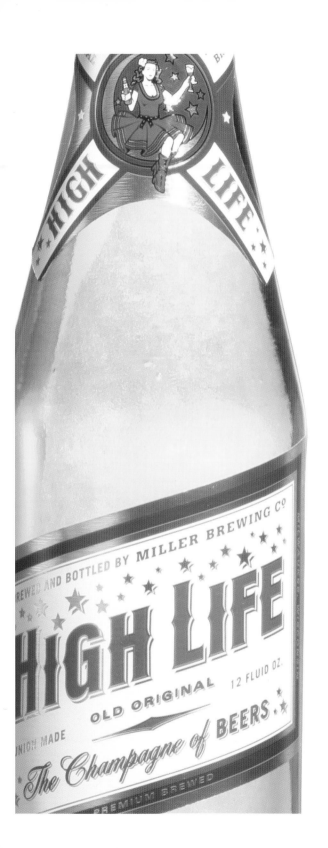

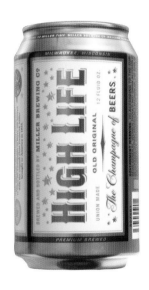

During the time that I was working on those long-term jobs (the Motorola project lasted for about two years), I found that it was important for me to work on some smaller, quicker projects as well. I designed a poster for a lecture on brand mythology, for example. I used the story of Icarus to visualize the subject, replacing the sun with the iconic "new" stamp that is found on so many products.

I also did a lot of work of my own on the side, such as this poster for the Push conference, a creative conference in Nashville, Tennessee. The brief here was to do a poster on creativity. Nothing is more paralyzing than being told to "do something on creativity." I ended up drawing this picture at four o'clock in the morning the night before the poster was due. I settled on an image of a bird waiting to take flight, because for me, half of the creative battle is just kind of jumping off.

KIDD. Real quick, how do you do type like that?

DYE. I just drew it.

KIDD. In...?

DYE. Well, I first drew it by hand. You know, a "sketch."

[*Laughter*]

I try to keep it old school with pencils and pads, and then later bring the design to the computer.

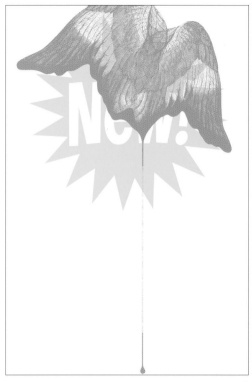

31

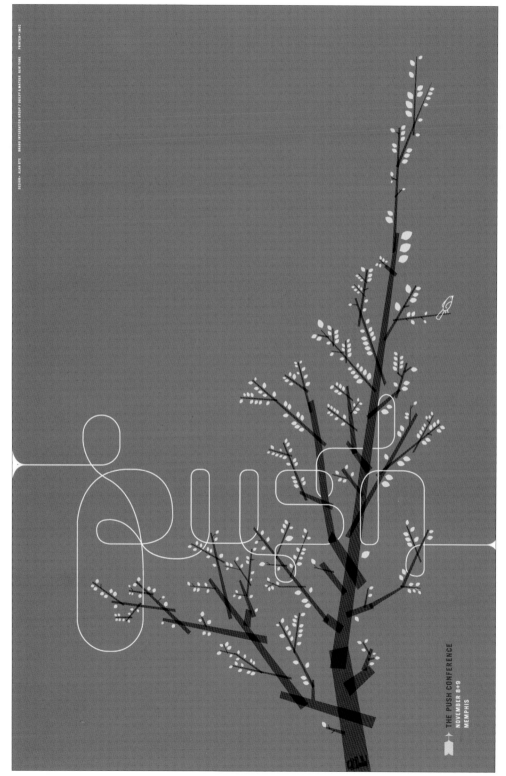

DESIGN – ALAN DYE BRAND INTEGRATION GROUP / OGILVY & MATHER NEW YORK PRINTER – IMSC

THE PUSH CONFERENCE
NOVEMBER 8+9
MEMPHIS

I also designed an identity for Diana Balmori's landscape architecture firm. Balmori wanted her logo to communicate nature and landscape, but she asked me not to rely on any of the typical references to nature—no leaves, twigs, trees, green, and so on. So I came up with a system of modular type that reflected nature in its most basic form. The type extended into a series of logos that changed on each application. Like nature at its core, we combined common elements in different ways for various results.

[*Applause*]

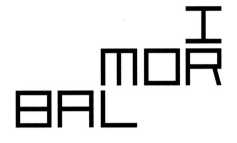

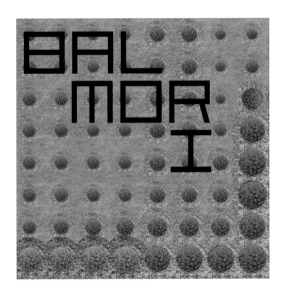

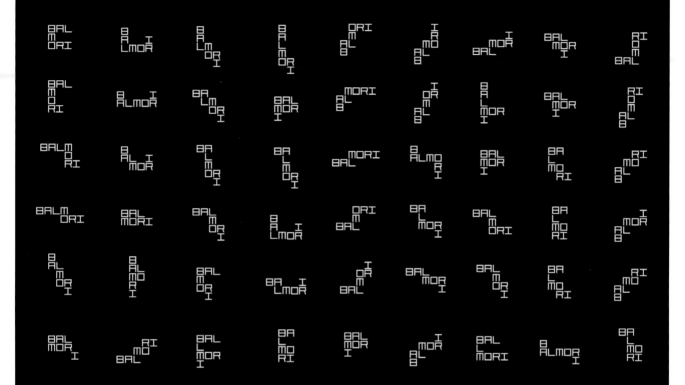

AGNIESZKA GASPARSKA. Directly after graduating
from the Cooper Union School of Art, I started
working at a company called Funny Garbage, a
design studio in SoHo that specializes in interactive
design and other applications of new technology. We
worked on a great variety of projects ranging from
large entertainment websites to interactive games and
from museum kiosks to large business projects. As a
young designer, it was great for me to be in an envi-
ronment where I constantly had to try something
new, approaching each job from a different angle in
order to find the appropriate design solution. That
method has stuck with me through these last few
years. Obviously, every designer has a certain style
that people can identify, but when I work on a
project, I try to focus on the goals of that particular
client, allowing the content to inform the ultimate
design solution.

34

One of my favorite projects during my time at
Funny Garbage was a set of kiosks for the Experience
Music Project in Seattle, a museum dedicated to
creativity and innovation in popular music. Funny
Garbage was hired to create a series of kiosks for
various exhibition spaces throughout the museum.
The two that I designed presented the history of the
electric guitar and the acoustic guitar.

When I began working on the first kiosk,
focusing on the electric guitar, I did a lot of research
looking for images of old, weird inventions—ampli-
fiers, instruments, and all kinds of gadgets. I thought
it might be interesting to create a kind of time-
machine interface that referenced all of the inven-
tions that led up to the creation of the electric guitar
and amplifier as we know them today. I looked at

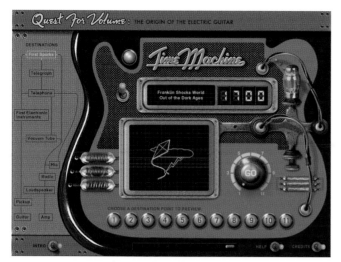

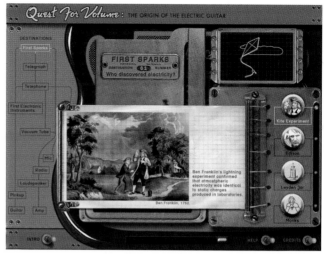

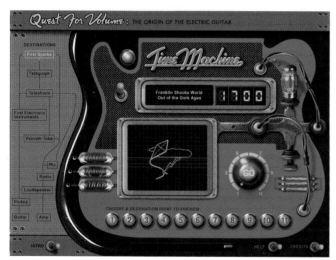

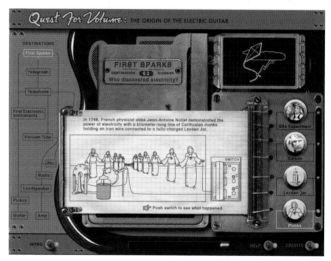

many different images for inspiration and developed the interface as a collage of all these diverse objects. When you interact with the kiosk, parts of it light up, panels fold out, there's an amplifier simulation, and you can play with Morse code—it's basically a big, weird machine. The design process was a great marriage of complex information design—the time line had to span the invention of electricity in the 1700s to the development of the current electric guitar—and a rich visual language. The kiosk ran off a hard drive, so I didn't have to worry about file sizes, modem issues, or bandwidth and was free to create this crazy collage.

35 The sister project to that kiosk was one focusing on the history of the acoustic guitar. In this case, the design was based on the shape and texture of a real acoustic guitar. The programmer who coded the kiosk had a lot of fun creating various special effects. If you tap on parts of the wood, it produces thud sounds; you can strum the guitar strings and sample sound effects from various guitar models.

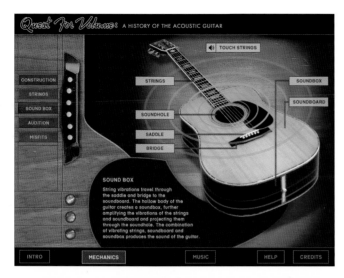

CONSTRUCTION
STRINGS
SOUND BOX
AUDITION
MISFITS

TOUCH STRINGS

STRINGS
SOUNDHOLE
SADDLE
BRIDGE

SOUNDBOX
SOUNDBOARD

SOUND BOX

String vibrations travel through the saddle and bridge to the soundboard. The hollow body of the guitar creates a soundbox, further amplifying the vibrations of the strings and soundboard and projecting them through the soundhole. The combination of vibrating strings, soundboard and soundbox produces the sound of the guitar.

INTRO | MECHANICS | MUSIC | HELP | CREDITS

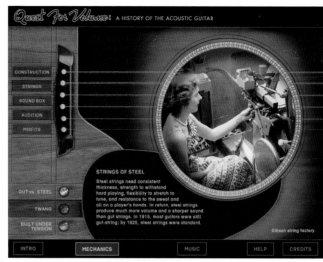

CONSTRUCTION
STRINGS
SOUND BOX
AUDITION
MISFITS

GUT-vs. STEEL
TWANG
BUILT UNDER TENSION

STRINGS OF STEEL

Steel strings need consistent thickness, strength to withstand hard playing, flexibility to stretch to tune, and resistance to the sweat and oil on a player's hands. In return, steel strings produce much more volume and a sharper sound than gut strings. In 1915, most guitars were still gut-string; by 1925, steel strings were standard.

Gibson string factory.

INTRO | MECHANICS | MUSIC | HELP | CREDITS

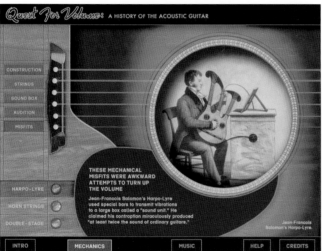

CONSTRUCTION
STRINGS
SOUND BOX
AUDITION
MISFITS

HARPO-LYRE
HORN STRINGS
DOUBLE-STAGE

THESE MECHANICAL MISFITS WERE AWKWARD ATTEMPTS TO TURN UP THE VOLUME

Jean-Francois Salomon's Harpo-Lyre used special bars to transmit vibrations to a large box called a "sound unit." He claimed his contraption miraculously produced "at least twice the sound of ordinary guitars."

Jean-Francois
Salomon's Harpo-Lyre.

INTRO | MECHANICS | MUSIC | HELP | CREDITS

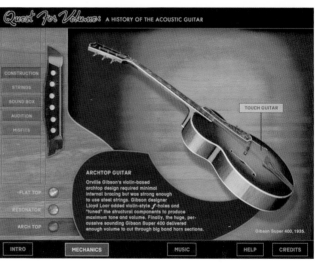

CONSTRUCTION
STRINGS
SOUND BOX
AUDITION
MISFITS

FLAT TOP
RESONATOR
ARCH TOP

TOUCH GUITAR

ARCHTOP GUITAR

Orville Gibson's violin-based archtop design required minimal internal bracing but was strong enough to use steel strings. Gibson designer Lloyd Loar added violin-style ƒ-holes and "tuned" the structural components to produce maximum tone and volume. Finally, the huge, percussive sounding Gibson Super 400 delivered enough volume to cut through big band horn sections.

Gibson Super 400, 1935.

INTRO | MECHANICS | MUSIC | HELP | CREDITS

36
37

A very different project that I worked on was a website redesign for Bloomberg, an international financial news company. Before Funny Garbage was approached to redesign it, the site had been around for years and was a bit outdated and dry-looking. The content that Bloomberg provides on its website was something we had to greatly respect. The redesign was thus mostly a question of well-structured organization and good information design. Even though the ultimate design was very clean and minimal, this project was still an interesting challenge from a design standpoint: making something that was inherently quite dry-looking a lot more digestible and attractive, while maintaining the same amount of complex content. The final design was essentially achieved by establishing a hierarchy and using the information and data as inspiration rather than as an obstacle. The visual content of the web pages still consists of data, charts, and numbers, but by organizing the space better and adding some color, everything became a bit more pleasant to look at.

KIDD. Does Bloomberg still use the site?

GASPARSKA. Yes, the site is about a year old, so it's still up and probably will be for a while. There's a huge database that drives all this information, so it involves a lot of work to redo the design.

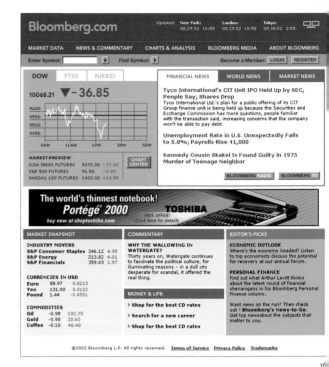

36

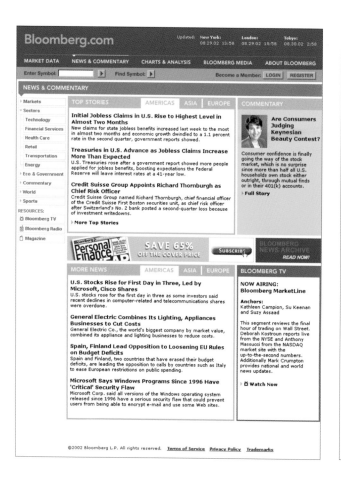

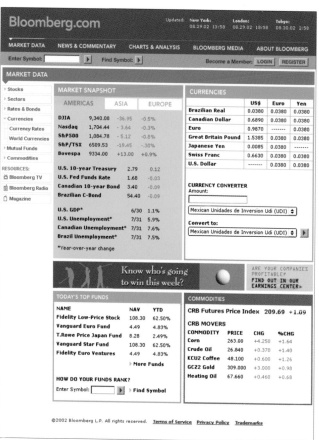

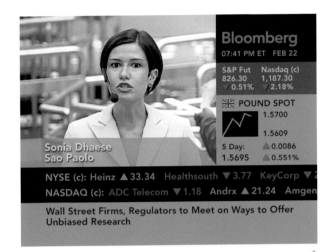

The second part of the Bloomberg project was the development of the Bloomberg corporate site, which is essentially a PR tool for the company. The site serves as a means to showcase the firm and help recruit smart, young people for Bloomberg's international offices. The company takes pride in its worldwide offices, so as an inspiration for my design I looked at the impressive interior design choices that are evident throughout Bloomberg's workplaces. The corporate site is a little bit more playful than the public information site, but it is still obvious that this is the site of a corporate financial information company.

Having designed these two websites, Funny Garbage also got involved in the redesign of the Bloomberg Broadcast screen. The Bloomberg channel is notorious for having a screen on which a zillion different things are going on all at once, with numerous tickers moving around that are fed by all kinds of information. There wasn't really much we could do about the amount of information that is visible on the screen, but we were at least able to remove a lot of extraneous elements that were supposed to make the channel look high-tech but just contributed to making it much busier than it needed to be. The original design of the screen had a brushed steel background, which was the first thing to go. Our redesign was mostly a question of simplifying the look and making it consistent with the changes that we had made to the two websites.

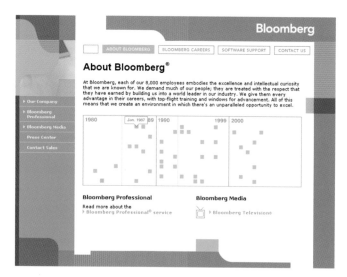

During my time at Funny Garbage, I also
worked on a variety of projects in my spare time. For
example, I developed a website for the art band
Fischerspooner. Fischerspooner is sort of a pop circus
troupe that incorporates elaborate costumes, choreog-
raphy, multimedia, and special effects into its per-
formances, walking the line between pop music and
performance art. The band is represented both by
Capitol Records and the Deitch Projects gallery in
New York. Their website was created about two years
ago, at the same time the band was developing
costumes and visual imagery for a new album and a
new series of shows. When they hired me to work on
the site, they gave me a huge book with all these
amazing, beautiful images that they were using to
create textiles and costumes. I think that is actually
one of the greatest things a client can do for you—to
give you a lot of material to look at and be inspired
by. Based on these images, I came up with a design
for the website, which is super-ornamental and
decorative. It has a variety of ornate elements
juxtaposed with geometric patterns, hand-drawn
fonts, and intricate illustrations. I loved being able
to design something playful like this while I was
working on projects like the Bloomberg sites at
Funny Garbage. It allowed me to flex my muscles a
little bit differently.

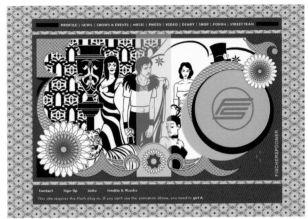

40

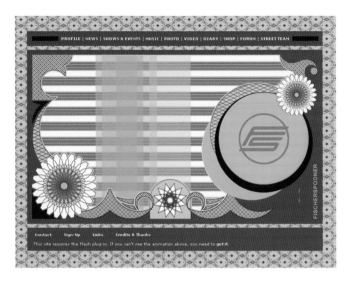

PROFILE | NEWS | SHOWS & EVENTS | MUSIC | PHOTO | VIDEO | DIARY | SHOP | FORUM | STREET TEAM

FISCHERSPOONER

Contact Sign-Up Links Credits & Thanks
This site requires the Flash plug-in. If you can't see the animation above, you need to **get it**.

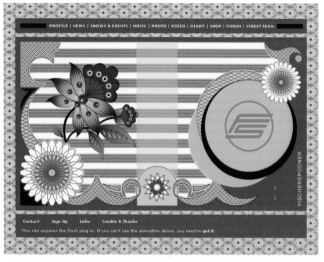

PROFILE | NEWS | SHOWS & EVENTS | MUSIC | PHOTO | VIDEO | DIARY | SHOP | FORUM | STREET TEAM

FISCHERSPOONER

Contact Sign-Up Links Credits & Thanks
This site requires the Flash plug-in. If you can't see the animation above, you need to **get it**.

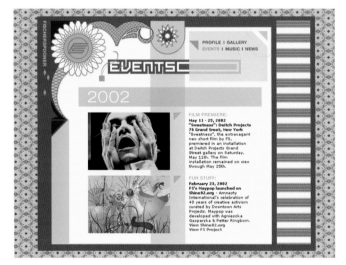

FISCHERSPOONER

PROFILE | GALLERY
EVENTS | MUSIC | NEWS

EVENTS

2002

FILM PREMIERE:
May 11 - 25, 2002
"Sweetness": Deitch Projects
76 Grand Street, New York
"Sweetness", the extravagant
new short film by FS,
premiered in an installation
at Deitch Projects Grand
Street gallery on Saturday,
May 11th. The film
installation remained on view
through May 25th.

FUN STUFF:
February 23, 2002
FS's Maypop launched on
Shine02.org - Amnesty
International's celebration of
40 years of creative activism
curated by Downtown Arts
Projects. Maypop was
developed with Agnieszka
Gasparska & Petter Ringbom.
View Shine02.org
View FS Project

FISCHERSPOONER

PROFILE | GALLERY
EVENTS | MUSIC | NEWS

GALLERY

SPRING 2002

Photo: Roe Ethridge

"GUILTY PLEASURE TRANSFORMED
INTO RECKLESS ECSTASY" – VILLAGE VOICE

42 Another project I worked on in my spare time was the identity and website for accessory designer David Mason. His work is defined by an unusual mix of innocent and evil, candy-coated and nasty; it's sweet and scary at the same time. He gave me a lot of material to look at that embodied this juxtaposition aesthetically. Based on these references and the variety of objects that Mason produces, I created an identity for him that has a sweet, bright-colored palette but is also a bit fierce and daunting. This aesthetic was then translated into a website that takes all the playful elements and puts them in motion, creating a little world of sweet and naughty parts.

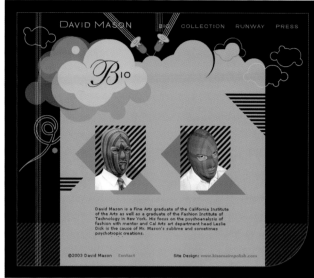

43 The last project I'm going to show is yet again at another end of the spectrum. I was asked to create a chart insert for a book entitled *Super Vision*, a publication by Ivan Amato showcasing images of objects at all of the visible size scales that exist in the universe. The goal of the chart was to help explain the scale relationships to the reader. Since the objects represented in the book span an immense range of dimensions, the challenge was to create a diagram that puts it all into perspective. As there weren't any visual references for the chart—just information—the design process was completely different from that of the Fischerspooner or David Mason websites. The design solution was dictated by the various size scales and their relationships.

[*Applause*]

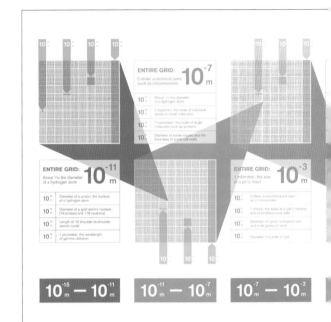

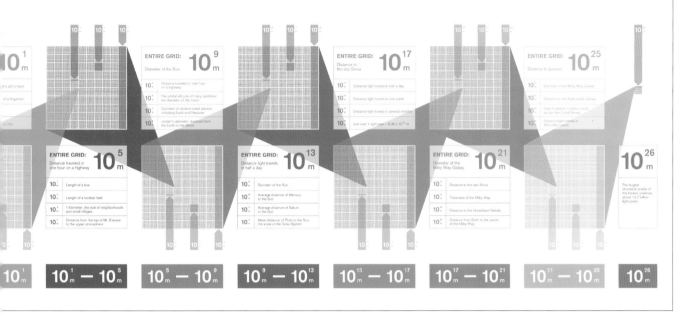

10^1_m

of a pin's head
of a fingernail

ENTIRE GRID: 10^9_m
Diameter of the Sun

$10^.$ Distance travelled in one hour on a highway
$10^.$ The orbital altitude of many satellites; the diameter of the moon
$10^.$ Diameter of modest-sized planets, including Earth and Neptune
$10^.$ Jupiter's diameter; distance from the Earth to the Moon

ENTIRE GRID: 10^{17}_m
Distance to the star Sirius

$10^.$ Distance light travels in half a day
$10^.$ Distance light travels in one week
$10^.$ Distance light travels in several months
$10^.$ Just over 1 light-year = 9.46 x 10^{15} m

ENTIRE GRID: 10^{25}_m
Distance to quasars

$10^.$ Diameter of the Milky Way Galaxy
$10^.$ Distance to the Andromeda Galaxy
$10^.$ Size of galactic clusters, such as our own Local Group
$10^.$ Distance light travels in 100 million years

ENTIRE GRID: 10^5_m
Distance travelled in one hour on a highway

$10^.$ Length of a bus
$10^.$ Length of a football field
$10^.$ 1 kilometer, the size of neighborhoods and small villages
$10^.$ Distance from the top of Mt. Everest to the upper atmosphere

ENTIRE GRID: 10^{13}_m
Distance light travels in half a day

$10^.$ Diameter of the Sun
$10^.$ Average distance of Mercury to the Sun
$10^.$ Average distance of Saturn to the Sun
$10^.$ Mean distance of Pluto to the Sun, the scale of the Solar System

ENTIRE GRID: 10^{21}_m
Diameter of the Milky Way Galaxy

$10^.$ Distance to the star Sirius
$10^.$ Thickness of the Milky Way
$10^.$ Distance to the Horsehead Nebula
$10^.$ Distance from Earth to the center of the Milky Way

10^{26}_m

The largest structural scales of the known universe; about 13.7 billion light years.

10^1_m $10^1_m - 10^5_m$ $10^5_m - 10^9_m$ $10^9_m - 10^{13}_m$ $10^{13}_m - 10^{17}_m$ $10^{17}_m - 10^{21}_m$ $10^{21}_m - 10^{25}_m$ 10^{26}_m

ALICE CHUNG. Karen and I met at the design studio
2x4, where we worked side-by-side. Even though we
weren't always working on the same projects, we
would often look at each other's screens to see what
the other one was doing. I started at 2x4 straight out
of school; at that time, it was a fairly small studio
with three principals—Michael Rock, Susan Sellers,
and Georgie Stout—and about eight designers. A
great deal of the work was for artists, architects, and
culture-related organizations, so 2x4 became my
introduction to the world of art and architecture
in print.

I still have a soft spot for the very first project I
worked on while still a summer intern there. The
partners encouraged the designers to work independ-
ently, without too much direction from the top down,
and to me this project, the design of an issue of *ANY*
magazine, embodies the self-motivational character
of our work. Architecture New York (ANY) is an
organization that used to publish *ANY* magazine and
a series of books based on its annual architecture con-
ferences. 2x4 designed *ANY* until about 2001. While
the design of the magazine was based on a rigorous
grid and the limitation to two typefaces, there were
few other guidelines. The layout was allowed to be
very free and expressive.

The issue that I worked on was the joint issue
no. 19/20, with the theme "The Virtual House." For
no. 19, writers were asked to submit articles based on
the topic; the flip side (no. 20) featured architects'
work that related to the idea of a "virtual house." In
the design for no. 19 we explored different typologies
of the printed page. The layout of each article has a

44

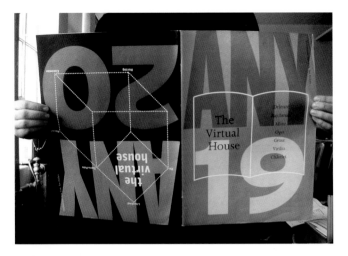

unique look and feel based on those different types. No. 20 was designed in contrast to the text-only no. 19, with the intention of giving the reader a more visual and immersive experience.

46

With the last conference in the series came the final issue of the magazine, *ANY* 27. The design toyed with the idea of "the end." Since we felt that the magazine didn't actually have a real end to it, we decided to leave the issue unbound and untrimmed, essentially unfinished. In order to access what was inside, the reader had to completely disassemble the pages.

KIDD. How many pages were in it?

CHUNG. I'm not quite sure, but I think it was eight signatures.

Another project at 2x4 was ANY's series of books on art and architecture. Vignelli Associates designed the first few, but 2x4 soon took over the design of the series. The last book in the series, *Anything*, was based on a conference of the same title. For the cover of this book, everyone in the studio created several designs. The final cover was a compilation of all those different pieces. That process reflected the way of working at 2x4, where often many people contributed to a single project.

[*Applause*]

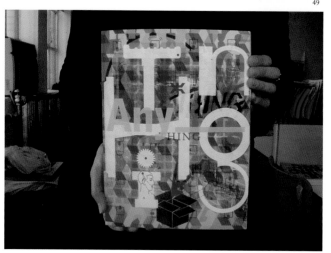

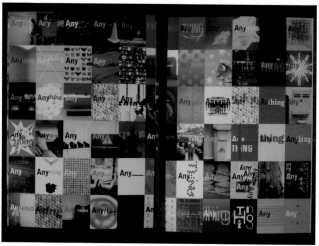

KAREN HSU. While I was at 2x4, the range of projects
I worked on was fairly diverse, reaching from logos,
identity systems, advertising, illustration, and invita-
tions to a few large-scale environmental signage
architectural collaborations. One of these large-scale
projects was the first Prada wallpaper installation for
the Prada store in SoHo, which was a close collabora-
tion with the store architects, Rem Koolhaas's Office
for Metropolitan Architecture (OMA). This project
was particularly fascinating for me because I have a
personal interest in wallpaper patterns. It was also an
exercise in exploration because our process was
defined by numerous small steps that each had to be
approved before we could move on. After we deter-
mined that the overall direction of the design would
be a bulbous, voluptuous floral pattern, we did a den-
sity study to establish the scale of the pattern. We

ended up choosing the middle one to pursue and then
looked at different variations—we considered whether
the pattern should be more somber and whether the
floral pattern could be made tougher by turning it
into camouflage. We thought about using the pattern
as a veil over Italian comics and discussed whether it
could be stenciled on top of wheat-pasted Italian
posters. Eventually, we started thinking of the pattern
as a series of windows for photographic images.

KIDD. Who was the actual client that you were dealing
with? Was it Rem Koolhaas or the people at Prada?

HSU. It was mostly the architecture firm, specifically the
project's lead architects, Ole Scheeren, Eric Chang,
and Tim Archambault. Eventually the designs were
presented to Prada, but before then there were many
internal presentations and critiques with the architects.

53

54

We decided to incorporate photographic imagery because the diversity of the images helped unite the wallpaper with the in-store video display, which was produced by 2x4, Keira Alexandra (an outside creative consultant hired by 2x4 for the project), OMA, and AMO (OMA's think tank/research offshoot company). We chose images that referenced Italianness, shopping, consumption, fashion, manufacturing, beauty, and sex. The final pattern overlays an X-shaped grid that weaves the images into each other so that individual images became less visually active and more part of a single image plane.

The installation was an entire block long, from Mercer Street to Broadway, with the semblance of repetition without actually repeating. Close up, the images are pixelated; they are legible only from a distance. We included photographs of our pets', Little Max's and Chula's, fur in the pattern, hidden among the other imagery.

[*Laughter*]

[*Applause*]

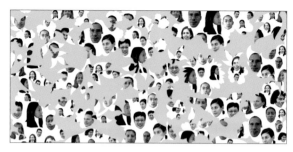

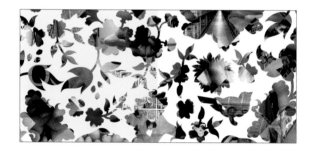

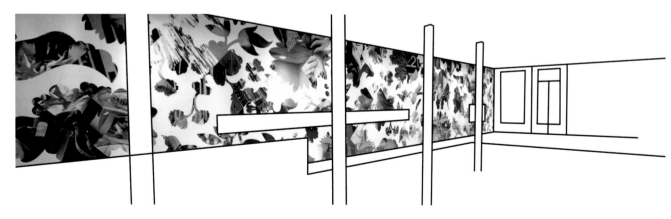

Where We Are

CORRAL. After my time at Grove/Atlantic ended, I accepted a position as art director at Doubleday Books. At first, working at Doubleday was a little overwhelming. Coming from a smaller publishing house, I was used to meetings that took place maybe once a month, or every two months, but at Doubleday there were meetings every week, and I soon understood that you were expected to deliver impact very quickly. During my first weeks, working on covers such as *Edgewater Angels* and *John Henry Days*, I simply continued what I had been doing at FSG—coming up with solid type treatments.

Soon after I started there, Chuck Palahniuk came over to Doubleday from W. W. Norton with his editor, Gerry Howard, and his new book, *Choke*. From attending meetings on the positioning of the novel, I got the impression that the people at Doubleday were not sure how *Choke* would be received. So when it came to the cover design, this is probably why they just said, "give it to the young guy in the corner."

KIDD. But the movie had come out? *Fight Club* had come out?

CORRAL. The movie had come out, yes.

KIDD. So Palahniuk was a big hit now, people knew who he was, and this was the first book that was going to be published after that?

CORRAL. Yes, I would have thought that they'd be jumping all over the design, but the publisher and the marketing director were not too concerned about it.

A Novel

Edgewater
Angels

SANDRO MEALLET

56

COLSON WHITEHEAD

John Henry
A Novel

Days.

★ Author of The Intuitionist ★

57

They didn't know whether Palahniuk's popularity was something that they could depend on and whether the book would sell.

Palahniuk's writing, both the language and content, is very visual, almost like a screenplay, with a lot of sex, throwing up, blood, and more sex. It was a good chance for me to become more creative again with my cover designs. It was also Palahniuk's first book at Doubleday, and when a house doesn't have defined expectations for an author yet, you have more freedom as a designer. With someone established, on the other hand—a John Grisham, for example— everything is spelled out, from typeface to point size.

The main character in *Choke* is a medical student who develops a scam to pay his mother's medical bills. He pretends to choke while dining in upscale restaurants. The people who "save" him from choking then feel responsible for his life and start sending him checks. Reading the novel, I got the impression that the book was a study of man, or a study of bad behavior. Instead of trying to pick a moment in the story and illustrate it, I wanted to simplify Palahniuk's message, so I chose this anatomical chart as an image. The type was kept almost uncomfortably large because I wasn't sure how the image would be received. Having the title and author big was safe and would help get the cover approved.

KIDD. How many versions of *Choke* did you have to do?

CORRAL. That was the only one.

KIDD. Was this unusual? How many versions do you usually end up doing? How many people are involved in finalizing the cover design?

CORRAL. I just got lucky with this one. Usually, I try to present a few options for each title, depending on the

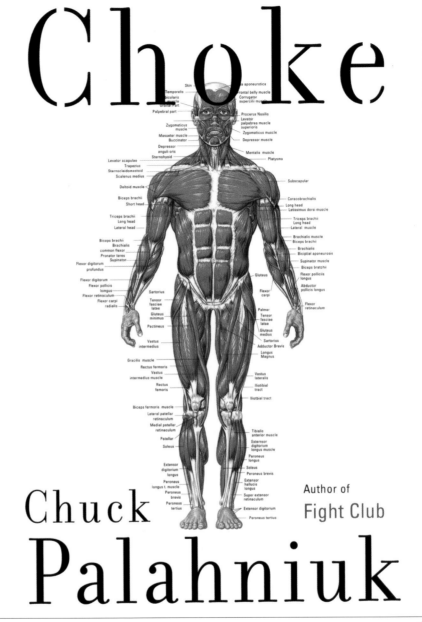

Choke

Chuck Palahniuk

Author of
Fight Club

book. There are a lot of people who have to see the cover before it goes to press, so at every step of the way changes can be made. There's the art director, the editor, the agent, the publisher, marketing and sales directors, and the author—even boyfriends or girlfriends of the author—who all weigh in. And of course they're all coming from different directions. What the author wants to see on the cover might be completely different from what the bookseller thinks will sell.

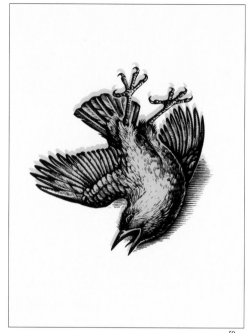

59

Palahniuk's next book was *Lullaby*, and again I was interested in the general idea behind the book. *Lullaby* is about a culling song that kills people and the man who discovers it when investigating sudden infant deaths. Young children die because their parents read the culling song as a lullaby before putting them to bed. The protagonist realizes that, if he repeats the song, either aloud or in his head, he has the power to kill the next person he thinks about. I knew that showing a dead child on a book would just not work, so I chose to put a bird on the cover.

59
60 We ran through a couple of rounds with this design. After deciding on the bird direction, it went to Joel Holland because I thought his illustration sensibility could work for *Lullaby*. Then it went on to Judy Lanfredi, a designer/illustrator friend of mine working at FSG in the children's department.
61 Together, we came up with this illustration of a sleeping/dead bird.

KIDD. Wait a minute. You had a cover there that had no type on the front. That's a major thing for a novel. Was that hard to get approved?

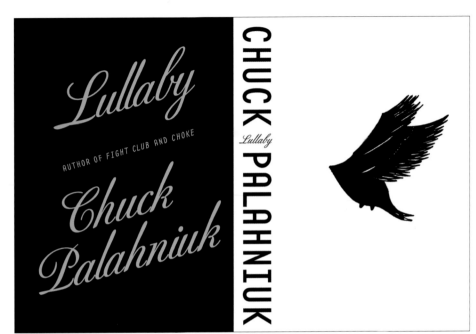

CORRAL. No, not at all. They just said…"okay." I wish
I had a better story, but I don't.

KIDD. They just fell for it hook, line, and sinker? "Oh,
I guess there's no type on the front…?"

[*Laughter*]

CORRAL. Well, when you're presenting book jackets, I
think it helps a lot to send the design wrapped
around a book, with a big, juicy spine, on which the
author's name is gigantic: CHUCK PALAHNIUK in
big, bright letters. The fluorescent type on the spine
helped my cause for having no type on the cover, but
the design wasn't about that anyway. It was really just
that his name is very long and not a very pretty last
name to put on a jacket.

[*Laughter*]

KIDD. How directly do you work with the author?

CORRAL. Not at all. I usually only get to see the cover
memos from the author to the editor.

Palahniuk's next novel, *Invisible Monsters*, tells
the story of a woman's life in Los Angeles as an
actress/model. She loses her job due to an accident
that leaves her disfigured, then loses her friends, her
wealth, and her fame. To convey her changing for-
tune, the cover focuses on an image that changes
depending on how you look at it. So this is the cover
straight up, and this is the cover upside down. I
placed the type upside down as well, so that it can be
read from either side.

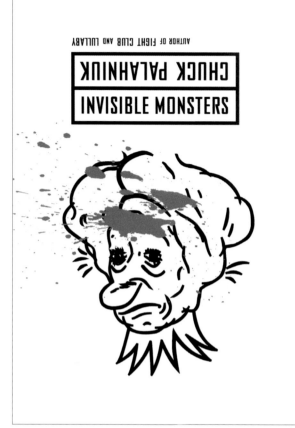

62

INVISIBLE MONSTERS

CHUCK PALAHNIUK

AUTHOR OF FIGHT CLUB AND LULLABY

By the time I designed the cover for Palahniuk's next book, *Diary*, I was getting a little tired of this approach with iconic images. I still wanted to achieve the same impact, but not through icons. In *Diary*, the main character is a contractor who slips into a coma. While he is in the coma, his wife discovers hidden messages that he had left behind on the walls of the houses he worked on. I wanted the cover to reference these handwritten messages, so I hired the illustrator Leanne Shapton to do the author's name and the title in hand-lettering. On the inside of the jacket, we printed one of the messages that the contractor leaves behind: "Where do you get your inspiration?"

65
66

The next project I worked on was Palahniuk's collection of short stories. I think this book gives an insight into Palahniuk's source of inspiration and tells you how much of his books' content pertains to his real life. This design illustrates a moment in the book, where a father has just killed his wife and is now looking for his son, who is hiding underneath the bed, in order to kill him next. I used photography for this jacket because it seemed appropriate for the book, which is a mixture of fact and fiction.

64

KIDD. Did you have that image shot? Or was it stock photography?

CORRAL. Michael Schmelling shot it. He actually had to reshoot the image, because it wasn't working out at first.

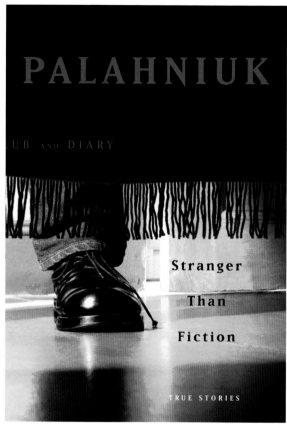

64

DIARY

A NOVEL

CHUCK DIARY

CHUCK PALAHNIUK

CHUCK PALAHNIUK

AUTHOR OF *FIGHT CLUB* AND *LULLABY*

CHUCK PALAHNIUK's novels are the bestselling *Lullaby* and *Fight Club* (which was made into a film by director David Fincher), *Survivor*, *Invisible Monsters*, and *Choke*. He lives in Portland, Oregon.

Visit the author at his official website—
www.chuckpalahniuk.net—
and at www.diary-book.com

Jacket design by Rodrigo Corral
Hand lettering by Leanne Shapton
Author photograph by Shawn Grose

www.doubleday.com

US $24.95/$35.95 CAN
ISBN 0-385-50947-7
52495

DOUBLEDAY

"CAN YOU FEEL THIS?"

"Just for the record, *Diary* is as hypnotic as a poised cobra. Chuck Palahniuk demonstrates that the most chilling special effects come not from Industrial Light and Magic but from the words of a gifted writer."
—Ira Levin, author of *Rosemary's Baby*

Chuck Palahniuk, the bestselling author of *Fight Club*, *Choke*, and *Lullaby*, continues his twenty-first-century reinvention of the horror novel in this scary and profound look at our quest for some sort of immortality.

Diary takes the form of a "coma diary" kept by one Misty Tracy Wilmot as her husband lies senseless in a hospital after a suicide attempt. Once she was an art student dreaming of creativity and freedom; now, after marrying Peter at school and being brought back to once quaint, now tourist-overrun Waytansea Island, she's been reduced to the condition of a resort-hotel maid. Peter, it turns out, has been hiding rooms in houses he's remodeled and scrawling vile messages all over the walls—an old habit of builders but dramatically overdone in Peter's case. Angry homeowners are suing left and right, and Misty's dreams of artistic greatness are in ashes. But then, as if possessed by the spirit of Maura Kinkaid, a fabled Waytansea artist of the nineteenth century, Misty begins painting again, compulsively. But can her newly discovered talent be part of a larger, darker plan? Of course it can . . .

Diary is a dark, hilarious, and poignant act of storytelling from America's favorite, most inventive nihilist. It is Chuck Palahniuk's finest novel yet.

WHERE DO YOU GET YOUR INSPIRATION?

67

By now I was officially the Chuck Palahniuk designer, so I recently repackaged *Fight Club* as a paperback. Most people have an image of this novel in their heads from the movie, and I felt I didn't need to reinvent or brand the book because it already had a huge following. With my design I just wanted to reinforce what people already thought.

[*Applause*]

$14.00
$19.95/CANADA

FICTION

"AN ASTONISHING DEBUT . . . *FIGHT CLUB* IS A DARK,
UNSETTLING, AND NERVE-CHAFING SATIRE."
—*THE SEATTLE TIMES*

In this darkly funny first novel that made Chuck Palahniuk's reputation as
his generation's most visionary satirist, an estranged young man seeks
relief from the emptiness of his work and life in the enigmatic figure of Tyler
Durden. Flaunting his disregard for the stultifying conventions of a hollow
consumer culture, Tyler devises a series of secret after-hours boxing matches
held in the basements of bars. Fight Club offers a way for Tyler and his
friends to overcome the frustrations of their professional and personal lives,
and his idea catches on quickly. But in Tyler's world, there are no rules, no
limits, no brakes.

 An underground classic since its first publication in 1996, *Fight
Club* is now recognized as one of the most original and provocative novels
published in the last decade. In an insightful new introduction, the author
discusses why the story will resonate with readers now more than ever.

"A powerful, dark, original novel . . . A memorable debut by an important writer."
—ROBERT STONE

"*Fight Club* offers diabolically sharp and funny writing."
—THE WASHINGTON POST BOOK WORLD

CHUCK PALAHNIUK
is the bestselling author of
Diary, Lullaby, and *Choke.*
He lives and works in
Portland, Oregon.

COVER PHOTOGRAPH BY MICHAEL SCHMELLING
COVER DESIGN BY RODRIGO CORRAL

DISTRIBUTED IN CANADA BY H. B. FENN AND COMPANY LTD.

ISBN 0-8050-7647-6

CHUCK PALAHNIUK

OWL BOOKS

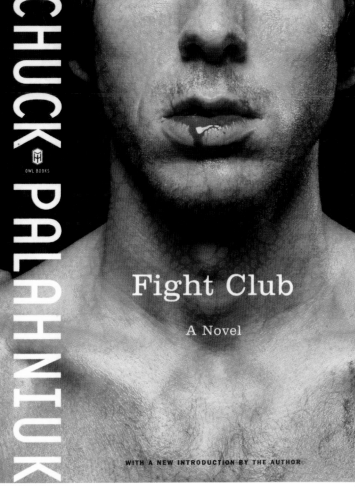

Fight Club

A Novel

WITH A NEW INTRODUCTION BY THE AUTHOR

DYE. During the end of my days at BIG, I worked on a couple of projects that I would like to share. The first is an identity proposal for the New York City 2012 Olympic bid. Obviously, this logo didn't get selected, but since it seemed like half the city worked on the logo, I thought I would show my contribution. Besides, it was a great project to be a part of. My submission was based on hand-drawn type combined with an image of the Statue of Liberty's crown. I thought the type was very New York City and the crown, another icon of our city, was a symbol of achievement. Apparently, the commission felt that the logo was both too athletic and too urban, which I thought was the whole idea from the beginning.

[*Laughter*]

Another logo I developed recently was a mark for Times Square. Instead of trying to cut through the visual noise that is inherent to Times Square we decided that we might as well just add to it, because cutting through wasn't going to happen anyway. We created a design that captured the energy of the square and evoked the feeling that you might get when being there. When we presented this work to the board of directors—essentially a group of prominent Times Square business people—one of the gentlemen in the back said, "You know, that logo really makes me dizzy." We took that as a compliment, saying, "Perfect, that's exactly what we were going for."

[*Laughter*]

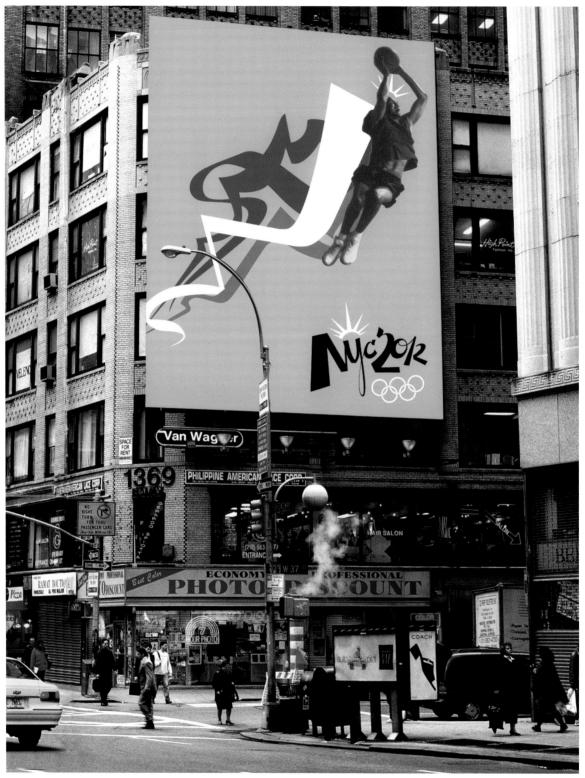

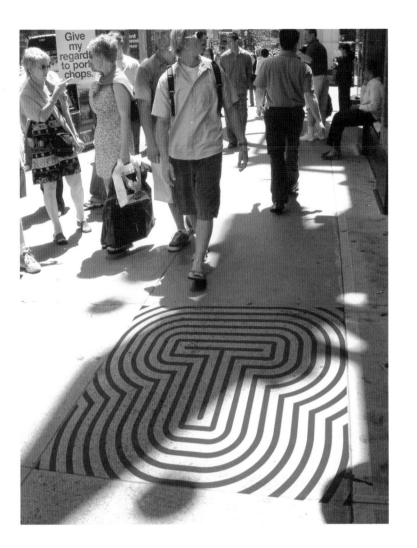

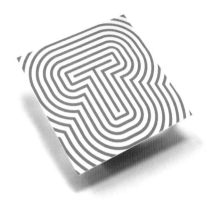

TIMES
SQUARE
ALLIANCE

ROBERT ESPOSITO
VICE PRESIDENT OF OPERATIONS

1560 BROADWAY, NEW YORK, NY 10036
T 212 768 1560 F 212 768 0233

BESPOSITO@TIMESSQUAREBID.ORG
WWW.TIMESSQUAREBID.ORG

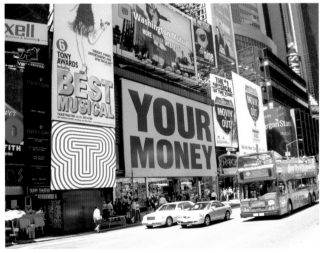

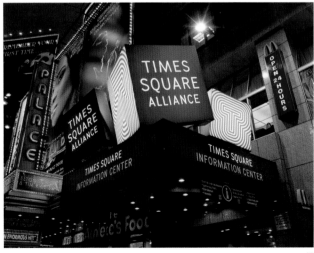

Around that time I had been at BIG for over three years. I had grown a lot working with Brian Collins and people like Michael Ian Kaye, but I think working with clients was starting to get me down a little bit and I felt the need to work in a smaller environment and in a more direct way. As luck would have it, I got a call from Julia Leach, the vice president of creative at Kate Spade, who was looking for a new design director. Well, needless to say, I was very interested because Kate Spade was a brand that I had always kept an eye on. I admired their use of design as a platform for building a brand and had always found their advertising campaigns fresh and innovative.

Moreover, I felt that this job would offer me the opportunity to take all that I had learned at BIG about developing a brand in a holistic way to a company for which I had a lot of respect. Kate Spade comes along with Jack Spade, another brand that I paid special attention to ever since they worked with Mike Mills on the film *Paperboys*. I knew that having these two brands to work on would be a challenge, but it would also be very interesting because they both have such different voices.

73 We recently worked on our 2005 agenda. The theme of the agenda was "time is luxury," so we shot images of things to do with your free time during each month of the year—from "clear away cobwebs" to "start a book collection."

74 These are some pieces from our recent ad cam-
75 paign for fall 2004. We wrote a short play that was performed on a white stage and captured moments from the performance. The story is about a girl named Sunday, who like a lot of people in the world these days is contemplating change—maybe a move to Switzerland? We had a lot of fun working on the shoot and developing a compelling story that not only highlighted our products but also provided an intriguing narrative.

KIDD. To what extent are you involved with ads like this? Do they give you the photo, or do you art direct the photo?

DYE. The team that I work with is responsible for every-thing. We art direct the photography, write copy, create the advertising, and all of Kate and Jack's design work—everything except for the products, and we design a good deal of those as well. Up until this point in my career I never had the chance to work in-house, so it's been a great experience for me. We work in a much more direct, tactile way—actually making things, writing our own copy, occasionally shooting our own photography, and authoring our own projects—essentially being our own clients.

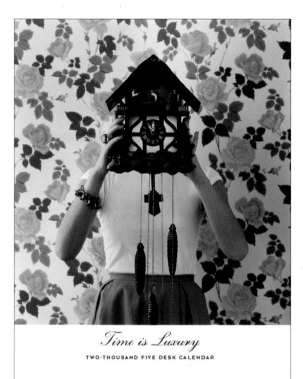

Time is Luxury

TWO-THOUSAND FIVE DESK CALENDAR

"MOVING IN ON SUNDAY" (ACT I, SCENE 1)

kate spade
NEW YORK

shoes handbags glasses

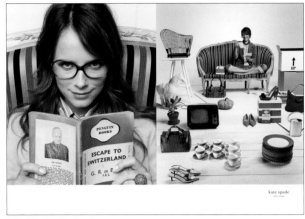

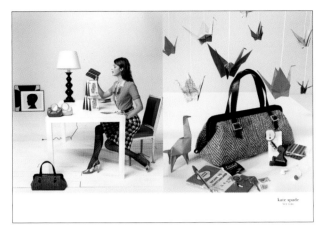

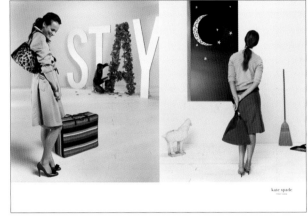

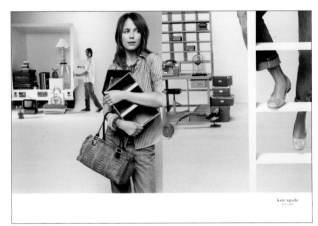

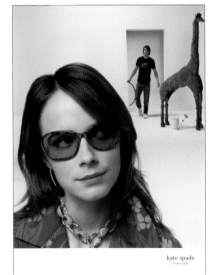

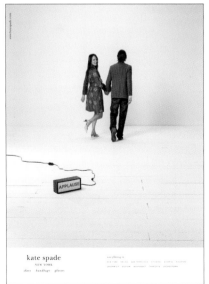

71 I've brought along some of the things we're cur-
72 rently working on: some holiday packaging; a look
76 book for Jack Spade, which, through perforation,
breaks down into product postcards and a short story
77 by Ben Greenman; and an ad that we ran in celebra-
tion of *PAPER* magazine's twentieth anniversary.

KIDD. Now, Jack Spade is Kate's husband, who's real
name is Andy Spade, right?

DYE. That's right, yes.

KIDD. Is that weird?

[*Laughter*]

DYE. Well, if you call him Jack it's a bit weird.

KIDD. No, I mean, is the dynamic of this husband-and-
wife team weird?

DYE. You know, they work very well together. It is truly
the two of them, as a team, that are the vision behind
the brand. Kate's very much involved in the products,
and in general, Andy looks more after the voice of
the brand.

At Kate Spade I've also been lucky enough to
inherit a wonderful group of designers; Cheree Berry,
Paulina Reyes, and Gillian Schwartz are all very tal-
ented people, so it's been an easy transition for me.

78 This book is something that we're publishing
with Jack Spade Press, an ongoing venture where we
self-publish books of everything from photography to
literature and short stories. It's called *The Bird* and is
a highly conceptual book that will be released in
spring 2005. See if you can figure out what holds the
images together...

[*Laughter*]

KIDD. I don't get it.

[*Laughter*]

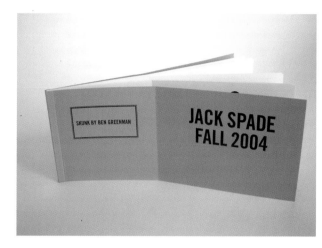

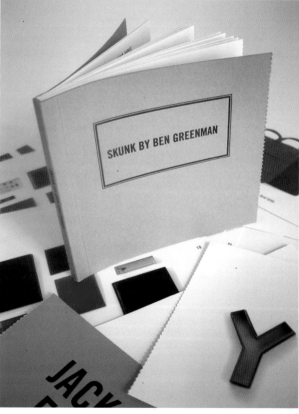

congratulations, paper, on twenty amazing years downtown.

kate spade
NEW YORK

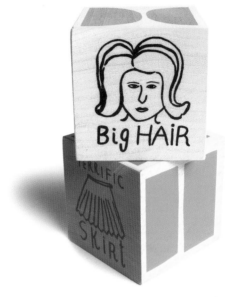

79

DYE. And finally, these are some images from a line of
baby and dog products that I'm working on together
with Maira Kalman—one of the wonderful artists
that we are lucky enough to collaborate with. In
this series we developed a set of baby blocks, which
do not only look beautiful but also have a bit of a
wink. For example, the matching block to the "big
hair" block has a little rabbit on it with the copy
"little hare."

 [*Applause*]

79

80

80

GASPARSKA. I made the switch from working full time at Funny Garbage to trying to start my own empire in the fall of 2003. It felt like a luxury to be able to spend my days working on my own projects with my own clients instead of doing that on weekends and at night, as had been the routine before.

81

One of the first projects I took on at this time was a website for Trunk Ltd., a vintage clothing company based in Los Angeles. They market a variety of products, among them a line of authentic re-issued versions of rock 'n' roll T-shirts from the sixties, seventies, and eighties. The firm was new and starting up at the time, but they already had a strong identity in place, which evoked the idea of a vintage trunk full of goodies. They wanted their website to bring to mind the same nostalgic feeling along with a rock 'n' roll circus vibe.

For me this was an ideal project to merge my past experience at Funny Garbage and my freelance pursuits. It combined what I'd learned heading up a design department in an office, dealing with the real business needs of clients, with my more independent work, which was more playful and loose. The various reference images that I had lying around while developing the site were all along the lines of the rock 'n' roll circus idea—colorful posters, hand-painted signs, colorful fonts, patterns, and vintage objects. While I played off the existing Trunk identity, I also added some other elements to it, such as bright colors to offset the muted palette of their brand and some vibrant geometric patterns. These are some stills from the animated intro of the website.

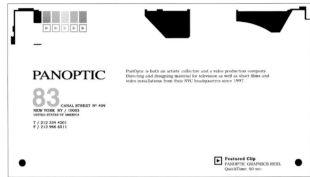

82
83

Another website I worked on around this time was for a company called Panoptic, a video production house specializing in music videos, films, animation, and commercials. They wanted their site to reference analog video tapes, packaging, and old VHS equipment. This was an interesting juxtaposition to Panoptic's portfolio of work since the firm doesn't actually do anything on analog any more—it's all digital; but there was something fun in using this type of dated classic aesthetic in this context.

The site in general is very clean and white, very businesslike, but it incorporates a lot of interactive elements. When you roll over the navigation, bright rainbow colors shoot out. When another section is selected, a bright, messy animation happens for a second, breaking up the pristine whiteness of the pages. It was interesting for me to go from something as ornamental as Trunk Ltd. to something as flat and straightforward as the Panoptic site.

82

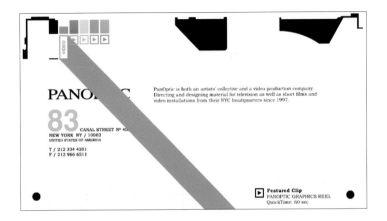

PanOptic is both an artists' collective and a video production company.
Directing and designing material for television as well as short films and
video installations from their NYC headquarters since 1997.

PANOPTIC

83 CANAL STREET Nº 40
NEW YORK NY / 10002
UNITED STATES OF AMERICA

T / 212 334 4201
F / 212 966 6511

▶ Featured Clip
PANOPTIC GRAPHICS REEL
QuickTime: 60 sec

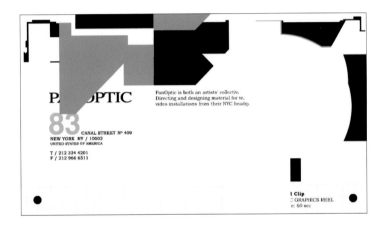

PanOptic is both an artists' collective.
Directing and designing material for te.
video installations from their NYC headq.

PANOPTIC

83 CANAL STREET Nº 409
NEW YORK NY / 10002
UNITED STATES OF AMERICA

T / 212 334 4201
F / 212 966 6511

l Clip
C GRAPHICS REEL
c: 60 sec

In an attempt to revitalize their fifteen-year-old view book, my alma mater, the Cooper Union, hired me to create a CD-ROM presentation that they could hand out to prospective students and supporters of the scholarship program. The CD was envisioned as a sort of interactive documentary on the school, giving people an idea of what the Cooper Union is all about.

One of the school's key assets is its location right in the middle of New York City. Instead of hiding the fact that the school has no campus, the Cooper Union decided to advertise that fact as an opportunity to experience the whole amazing city as the school's campus. A large part of the aesthetic direction in the design was therefore inspired by the various visual elements and patterns found looking around the East Village's busy streets. Shapes that reference the landscape surrounding the school were incorporated into all aspects of the CD-ROM: the negative spaces created by the outlines of buildings against the sky; the signature arches of the school's main building (a distinct landmark of the neighborhood); and the patterns created by layers and layers of postings that can be found on the walls of many of the Village's buildings. In the final presentation, all of these visual elements are animated and incorporated with almost two hours of recorded interviews of Cooper alumni, staff, and students, who talk about their experiences at the school.

[*Applause*]

CHUNG. Our design firm, Omnivore, is about two years
old now. We don't have an official studio space
because we both work from home, with our animals.
But we're constantly online with each other, or on the
phone, or meeting on Seventh Avenue somewhere, so
it's almost as though we were working side-by-side,
except we're handing things off on the subway, or...

HSU. In a taxi.

KIDD. What made you decide to open your own firm?
Did you find the transition from working at 2x4 to
being your own bosses difficult?

HSU. I had always wanted to work on my own, and in
many ways it felt like the right time. Learning how
to approach all aspects of design as a business (versus
design as a focused act) was exciting—both satisfying
and challenging.

85

CHUNG. As Karen said, the time just felt right. We
had been out of school for almost four years, and I
think part of the reason why we took that step was to
make a big change, where things are new again,
where one feels inspired again. The transition was
daunting—we learned a lot just by virtue of being
thrown into it.

One of the projects that we've recently finished
is the Whitney Biennial 2004 exhibition catalogue.

HSU. The three curators of the exhibition had the idea
to publish a catalogue that was more than just a book,
and we worked closely with them to develop this
concept. In the end we decided that the book would
be accompanied by a box of ephemera. The box
contains individual artists' submissions that were
created based on print guidelines we provided. The
exterior box and book cover design includes a shared

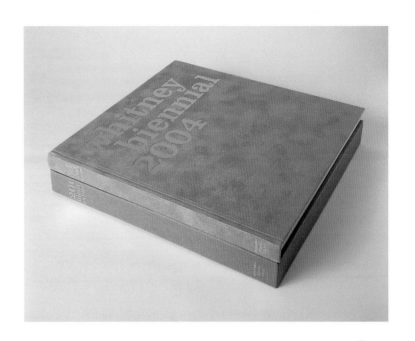

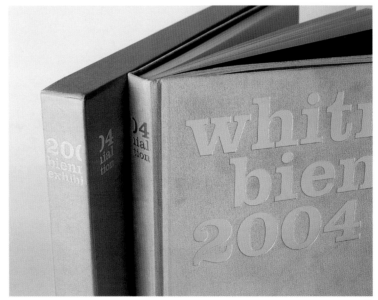

87 spine, to emphasize that the two things belong together as a set.

KIDD. So you basically commissioned each artist in the Whitney Biennial to create a piece of art for the catalogue? Had anybody ever done that before?

HSU. Maybe not for the Whitney Biennial.

CHUNG. There was a magazine from the sixties called *Aspen*, which was the basic inspiration. The form of *Aspen* changed from issue to issue, and sometimes its contents were presented in a box.

HSU. Originally, we wanted to offer a greater variety of options for artist submissions—including three-dimensional objects, customized die-cutting, perforation, and things like that. In the end, however, production and budget restraints restricted the number of templates for the pieces.

KIDD. How many artist pieces were included in each box?

CHUNG. Each of the 107 artists created a piece for the box, but they had to choose one of eight types of pieces to submit: an eight-page 'zine, a rectangular poster, a square poster, a round sticker, a bumper sticker, an uncoated square card, a glossy postcard, or a filmstrip. We created templates for each type, which they then used to create their individual pieces.

HSU. We were able to achieve greater diversity with the materiality, varying paper stocks within one type of template, for example, because the printer, Gerhard

88 Steidl, was very generous and flexible. In the book itself we tried to reference the eclectic visual texture of the artists' templates with the typography. We chose three different typefaces to represent the three voices of the three curators.

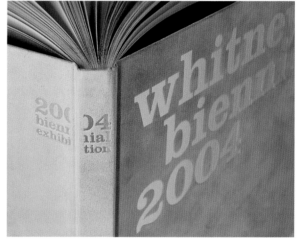

87

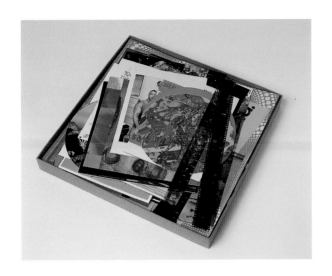

89

CHUNG. Another book we worked on was the Harvard
Graduate School of Design's (GSD) annual book
of student work. When the GSD came to us, they
wanted a departure from what they had been
producing for the past several years, a fairly straight-
forward black-and-white printed compilation of
student work.

 The school has three departments—architec-
ture, landscape architecture, and urban planning and
design—and each program is structured into two
parts, with core lessons in the first year of study and
optional studios in the subsequent years. Based on
that general structure, we decided that the book
should be in two parts, bound by a central shared
cover so that the outside of one cover literally
becomes the inside of the other. The interior pages
have a shifting grid as well, with sections of one
project starting on the spread of the previous project.

HSU. The grid slides horizontally throughout the
book, in an attempt to reference the folding of the
outside covers.

KIDD. Was it hard to convince the school to do this
two-part design?

CHUNG. No, they were actually very excited about this
different format. The production people in the design
program were a bit more hesitant, though, saying it
was too complicated.

 [*Laughs*]

HSU. Perhaps our oddest project ever was creating a
rooftop mural for the former president of Princeton
University, William Bowen. He has a house in
Avalon, New Jersey, that has many levels, decks, and
stairways from which you can look down onto a
rooftop, so he decided to paint a mural on the roof
deck. He wanted the design to incorporate the differ-
ent mascots of the universities that he and his wife,
his children, and his children's partners had attended.

[*Laughter*]

We looked at many ways of combining the
animals, and in the end went with a stylization of
the animals based on a particular rendering of the
Princeton tiger.

KIDD. And the reason you went through with this
is what?

[*Laughter*]

HSU. They paid us.

[*Laughter*]

CHUNG. And we like animals.

HSU. He felt that because our name was Omnivore we
would be the perfect people for the job.

[*Laughter*]

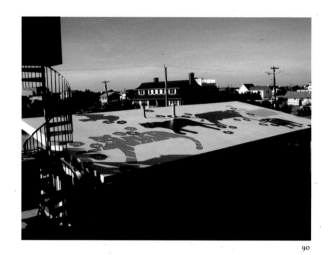

90

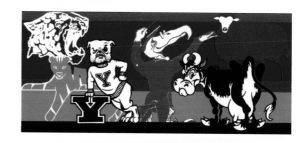

CHUNG. The next project was a collaboration with
 David Stark of Avi Adler, an event-design firm, who
 hired us to develop wallpapers for a Target pop-up
 store that opened in May 2004.

HSU. It was a temporary store in Bridgehampton, Long
 Island, located in a converted nineteenth-century inn.
 David's concept was to design every room of the
 store with a theme based on the products that would
 be sold in it. There were ten different rooms, plus a
 main hallway and stairs.

<div style="margin-left:1em; color:#888;">93
94
95
96</div>

 The first reading of a room feels appropriate
and quaint, but through our play on traditional pat-
terns, closer observation yields a series of surprises.
The wallpaper in the backyard barbecue room played
with the silhouette of a damask and incorporated
lobsters and steaks, with a white picket fence serving
as faux wainscoting; it was a Hamptons "surf 'n' turf,"
if you will. The bedroom pattern was supposed to feel
like a psychedelic toile. There were a few garden
rooms; one was for more formal garden accessories,
and its pattern used silhouettes of defined panels
with inset imagery.

CHUNG. We began the design of the Asian-inspired
 garden room with the idea of chinoiserie, but later
 expanded it by including other elements, such as the
 Eiffel Tower, to make it a bit more playful.

HSU. All of the wallpapers incorporated the Target logo,
 which was either obvious or more hidden. We also
 made large patterned Target-logo aprons for the
 store staff.

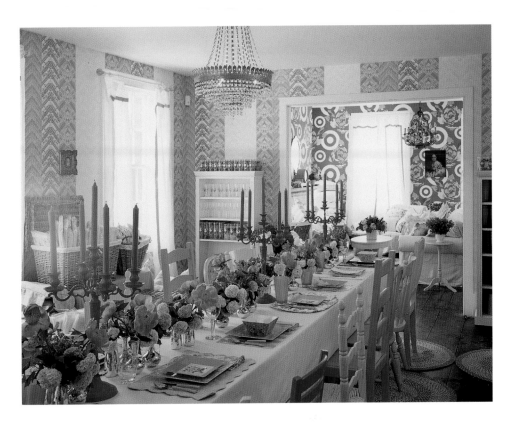

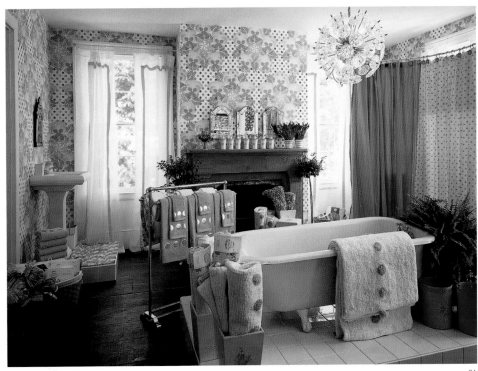

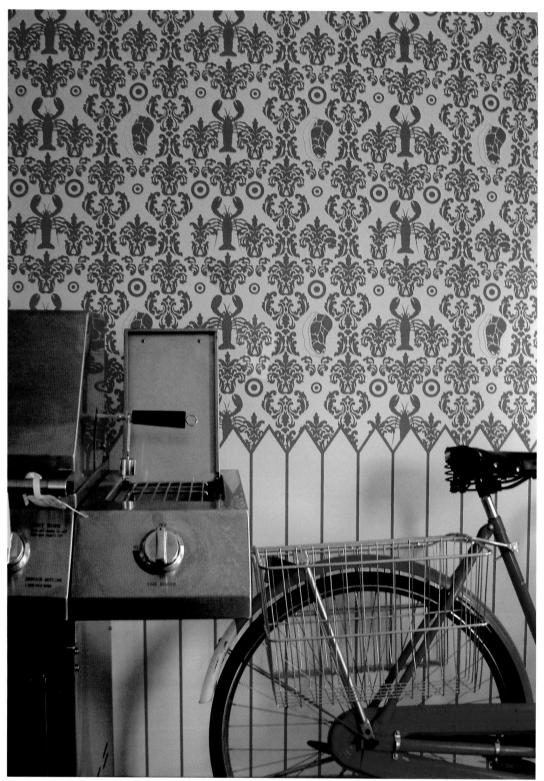

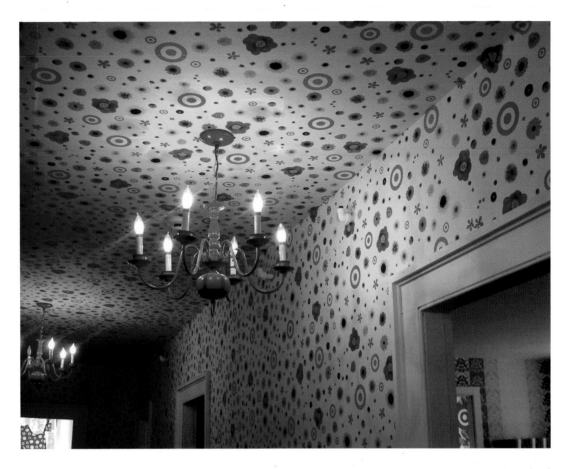

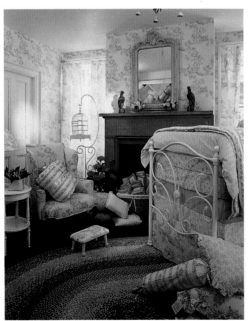

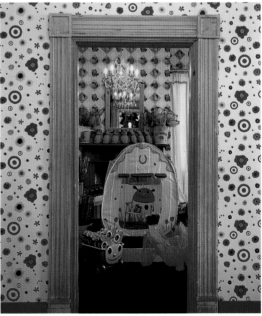

97

CHUNG. The next two projects were on a smaller scale but were also somewhat unusual in their format. We designed an invitation for Creative Time's Burlesque Bash, a benefit that was held at a Times Square venue called Show. The request was for people to dress sexy.

HSU. Based on the theme, we designed an invitation that took the form of three cards of stickers with the information printed on the back. We chose a color palette and created patterns that were festive and gaudy. The stickers could be peeled off and worn as pasties.

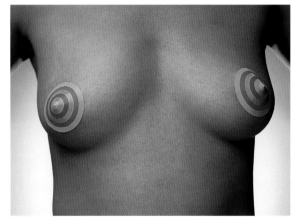

98

This last project, another collaboration with
Avi Adler, is a really indulgent bar mitzvah invita-
tion. The theme of the event was sports balls, because
the son of our client is an avid sports fan. For the
interior décor of the party space, a variety of sports
balls were used. Based on that, our design focused
on circles and spheres; in addition, we wanted to
reinvent the traditional, flat invitation card and make
the invitation itself more of an experience.

Our final design consisted of a custom telescope
box with a custom foam liner. Inside was a small
Lucite, or acrylic, box that had the party logo silk-
screened onto it. In this box were three invitation
cards. The cards were double-mounted, blind-
embossed with the party logo on one side, and foil-
stamped with the information on the other side.
Underneath the cards in the box was a nearly five-
inch-diameter solid milk chocolate hockey puck.

[*Laughter*]

The sad part of this project was that even
though we were very careful with all of the different
elements, the one big mistake we made was neglect-
ing to check the reply envelope postage. The square
envelopes had insufficient postage and were all held
up at the post office on Fifty-ninth Street and Third
Avenue. So we went over with a giant box of choco-
late and became really good friends with the Postage
Due clerk.

[*Laughter*]

KIDD. How many of these did you make?

HSU. There were almost two hundred.

KIDD. For some kid's bar mitzvah?

HSU. Yes...

[*Applause*]

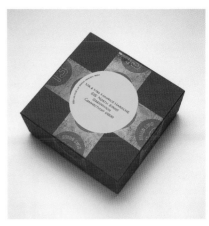

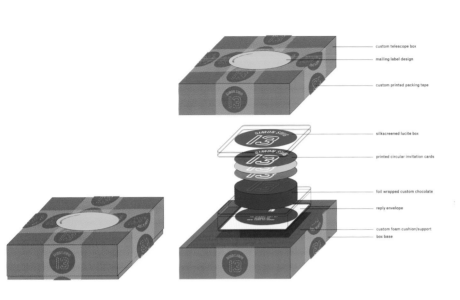

custom telescope box

mailing label design

custom printed packing tape

silkscreened lucite box

printed circular invitation cards

foil wrapped custom chocolate

reply envelope

custom foam cushion/support

box base

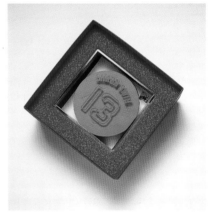

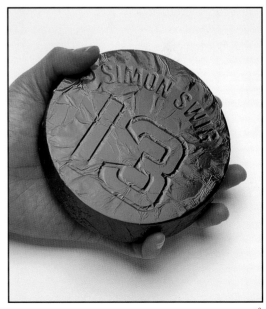

Where We Are Going

CORRAL. I have no clear idea where I want to be. Up to this point I haven't really had a plan, except to keep working and stretching myself as a designer. I opened my own studio about two years ago, after working at Doubleday for a year. I started the studio for a few reasons. First, Doubleday eliminated my position. Secondly, I wanted to do more designing and less art directing. Freelancing full time also gave me the advantage of working with a lot of different houses and on a variety of great books from everyone's lists. And finally, being on my own allows me to take on work other than book jackets, which has been great.

Recently, I was hired by Rick Valicenti to work on a promotional book for Fox River Paper Company's new line of paper. The paper was all post-consumer waste, and the book focused on other environmentally friendly products. Because we wanted to show how the paper could be used, I was able to make use of embossing, die-cutting, and other production methods. It was great to work on a whole thirty-page book from start to finish, not just a cover.

FOREVER GREEN

This tasty teacup, made simply of sugar, offers the latest conceptual thinking in total immersion retrieval from Droog Designer Nienke Vaneck.

MAKE IT LAST

Emeco Chair

Stronger than cork and tough enough to sustain a torpedo attack, Emeco's classic 1944 Navy chair was created with sustainability in mind. From 75 percent recycled aluminum, the chairs are designed to last a lifetime or 150 years — which ever comes first.

SUMMER BREEZE

Lawrence Convention Center

Rafael Viñoly's, David L. Lawrence Convention Center in Pittsburgh, cuts down on energy use by reaping the breeze benefits of an location on the Allegheny River. Fourteen ribbon-like sections of the roof keep the building naturally ventilated by drawing cool air off the water and releasing warm air at the top.

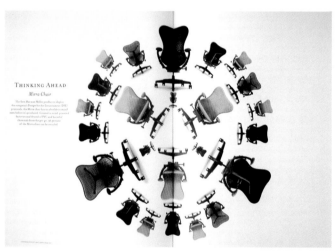

THINKING AHEAD

Mirra Chair

The first Herman Miller product to deploy the company's Design for the Environment (DfE) protocols, the Mirra chair has as a buckle to meet uses before it's produced. Created in steel-powered factories and devoid of PVC and harmful chemicals from the get-go, 96 percent of the Mirra chair can be recycled.

Even though I've been taking on different projects, the majority of my work continues to be book jackets. One of the jackets I worked on recently was for James Frey's memoir, *A Million Little Pieces*, in which he writes about finding himself in rehab for drugs and alcohol at twenty-three. I felt the cover needed to have a human element, so Fredrik Broden took this picture of a hand covered in candy sprinkles. The sprinkles look like little pills, and their amount is a direct reference to the title.

Another book I worked on, for Regan Books, is *Bush On the Couch*, by Justin A. Frank. It's a psychologist's analysis of President George W. Bush. After going through a few rounds, I boiled down the design to this huge question mark. "What the hell is he thinking?" is the question.

There's one particular point I want to make about this next cover, *The Triumph of Love Over Experience*. It's a nonfiction book about being divorced and finding love again twenty-five years later. It's a cute cover, and I see this as a sort of progression I made. I used to think that I'd never try to make things cute, because I always associated cute designs with having no idea. Now I feel I can design a cute cover and there can still be an idea behind it.

Above all, I'm trying to create work that allows people to come to their own conclusions. I'm not interested in "punchline" design. Instead, the reader can look at a jacket and think about how it relates to the book and his or her interpretation of it.

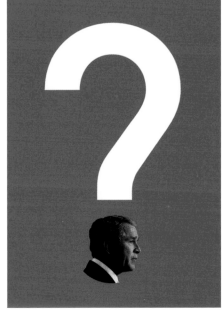

101

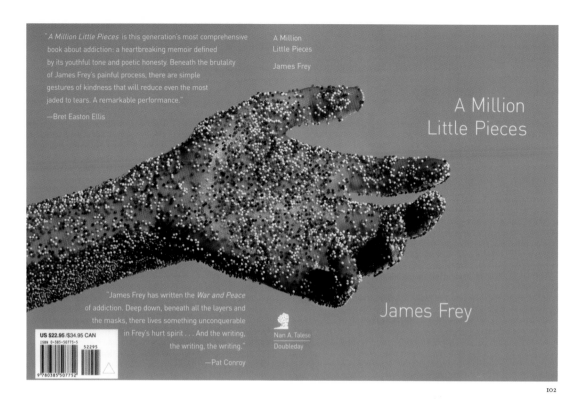

"*A Million Little Pieces* is this generation's most comprehensive book about addiction: a heartbreaking memoir defined by its youthful tone and poetic honesty. Beneath the brutality of James Frey's painful process, there are simple gestures of kindness that will reduce even the most jaded to tears. A remarkable performance."
—Bret Easton Ellis

A Million
Little Pieces

James Frey

A Million
Little Pieces

"James Frey has written the *War and Peace* of addiction. Deep down, beneath all the layers and the masks, there lives something unconquerable in Frey's hurt spirit . . . And the writing, the writing, the writing."
—Pat Conroy

US $22.95 /$34.95 CAN
ISBN 0-385-50775-5
52295
9 780385 507752

Nan A. Talese
Doubleday

James Frey

WENDY

The
TRIUMPH *of* LOVE
over EXPERIENCE

ONE
WOMAN'S
DECISION
TO
REMARRY

SWALLOW

WENDY SWALLOW
Author of Breaking Apart

104 *Jamesland*, by Michelle Huneven, is a paperback published by Vintage. In the first scene of the novel, the main character awakes in the middle of the night to find a deer in her house. Throughout the book deer keep popping up and lead the woman to answer the questions she has about life. At one point someone puts a flier on her porch with illustrations of deer on it, inviting her to a talk. For the cover design, I created a similar flier and then had Tamara Staples shoot it on a dark wood background to convey the atmosphere of an environment.

105 I've designed several jackets for the Polish poet Adam Zagajewski. This is a cover for his recent book of essays, *A Defense of Ardor*. Many of Zagajewski's essays deal with place, visualized here by Gus Powell's photograph. The depth of the image also speaks to the complexity of the ideas in the book. As a contrast, I kept the type treatment clean and simple.

106 *The Meaning of Sports*, by Michael Mandelbaum, is a book I worked on for Public Affairs. This was my favorite comp, but unfortunately it got rejected in favor of something more commercial. I thought the #1 finger was a symbol that encompassed all sports fans and was not specific to baseball, football, or basketball.

107 The last cover I would like to show is *Translation Nation*, by Hector Tobar, a book about the Spanish-speaking culture in America. Because religion plays a huge part in most Spanish-speaking cultures, I had Judy Lanfredi put a twist on a "sacred heart" illustration by replacing the heart with a map of the United States. I used hand lettering to keep with the organic feel of the painting.

[*Applause*]

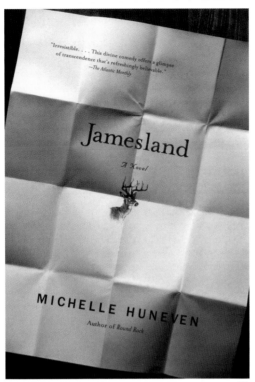

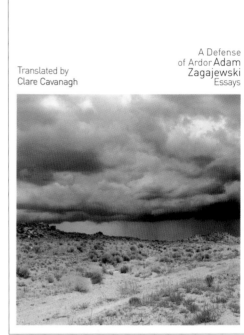

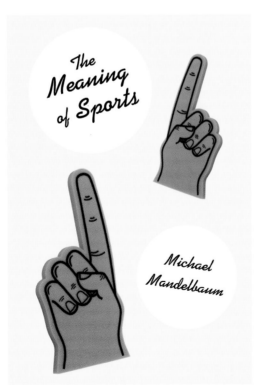

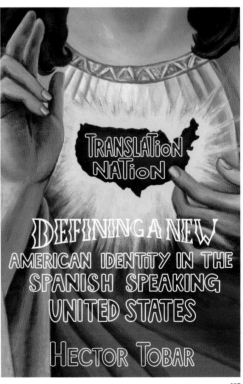

DYE. During my first weeks at kate spade, I made a list of short- and long-term goals and aspirations for the studio. As both of the brands continue to expand, the most important thing for me is to grow this studio into a place where we can continue to solve our problems in ways that allow for the sense of wit and charm that in my mind have become synonymous with Kate and Jack Spade. In the short term I want to start developing our own projects. Something that we're working on now, for example, is the Doghouse Book for Jack Spade, which is essentially an address book with an added feature that lets you keep a grudge tally. In other words, you can keep track of which of your friends are, or are not, in the doghouse. Some of the reasons we came up with for why a friend might be in the doghouse are, "Pours beer on the ground for the homies that aren't around," followed by, "Says homey."

[*Laughter*]

The other thing that I think is crucial for this studio is to continue to occasionally do some work for outside brands. Kate recently designed the uniforms for Song Airlines, and we've done a lot of their advertising work and just shot a TV spot for them. We also designed some posters for Song. This kind of work keeps us on our toes and proves our worth. It's always healthy for a studio to work on projects and with clients that are outside of the comfort zone. It helps to keep the designers interested and learning.

Finally, I want to continue our collaborations with artists. A couple of years ago Jack Spade collaborated with Evan Hecox on a limited edition, hand-shaped skateboard deck. I think the relationship that Kate Spade as a brand has had with the arts from its beginnings is paramount. In some ways, I feel that it's our main point of difference. Right now, for example, we're working together with Alexander Girard's estate to develop products that use some of his amazing drawings, which for me is a dream come true as he's always been one of my heroes.

As I look forward to the future, I think that what keeps me excited about working at Kate Spade is the opportunity to push the brand into places that from time to time might feel a little bit uncomfortable and unusual. It's always been these curveball projects, these kind of unusual products, that have allowed kate and Jack to remain fresh. I'm also looking forward to building a brand that has a distinct point of view on what it means to be a design and fashion company. So, whether it's new book projects, architecture, films, collaborations with writers or artists, or just new product ideas, we want to build a studio where people have the ability to continue to be creative, to solve problems in new, smart, and interesting ways, and always to remain fresh.

[*Applause*]

110
111

110

GASPARSKA. A lot of the projects that I'm working on right now are not yet complete, so unfortunately I can't show them. But in general, one of my first short-term goals is to move my office out of my house. I'm sure Karen and Alice can sympathize. It would be great to have a space outside of my home (which is supposed to be warm and relaxing, not stress-ridden), where I can work, bring clients, and feel okay about working like a maniac. Not that I mind working in my pajamas, but it has its drawbacks. The other thing I would like to move toward is expanding my work to other media that aren't just made to live in cyberspace or on a computer somewhere. As fun as designing interactive projects is, one of the reasons why I decided to start my own studio was to be able to apply my design skills to a variety of things without bandwidth limitations. This has actually turned out be a bit of a challenge because everyone is defined by what they have done in the past, and clients approach you because of projects they have seen you do well. But I would like to work harder at breaking that kind of pigeonholing. In the meantime, I'm trying to do as much as I can to take it one step at a time.

I recently did an illustration for a magazine, for example. I haven't had the chance to do a lot of illustration work, but this was a fun exercise. The magazine—*Exclusiv*, based in Warsaw—approached me to create a layout for all these little gadgets they were featuring, which allowed me to create a landscape composed of some drawings I had developed for other work, combined with new illustrations. It was great to work in print for a change.

112

113

114

115

116 I also worked on the packaging for a new brand of pizza bread. The product is called Hot Mama—yes!—and is currently being sold at Wal-Mart. The existing packaging was not giving the pizza bread the positive attention it needed, so I collaborated with another firm to help spruce it up. We didn't necessarily reinvent the wheel, but it was a great exercise to work within the accepted boundaries of supermarket packaging design.

117 Another project I recently worked on was for a new magazine called *Team Rad*. My boyfriend and I designed these playful title cards for the magazine's website. They're basically one-off layouts of the magazine's name that are displayed on its home page but will also be used as postcards, posters, or T-shirts. It was a lot of fun to create these silly things—designs that you wouldn't necessarily be able to do for any straight-laced client. This is exactly what I would love to continue doing in my work—having a lot of fun with a lot of different projects.

[*Applause*]

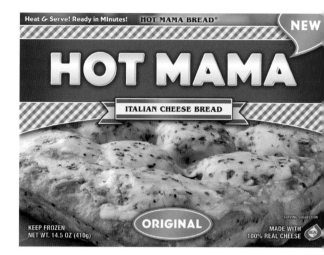

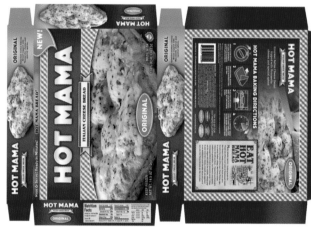

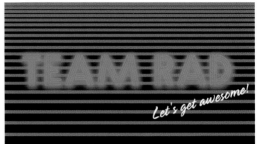

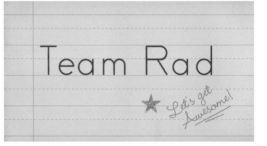

HSU. We imagine that in the future we could be
118 working from almost anywhere and that all we
really need is a good Internet connection, our pets,
and phones.

CHUNG. Part of what we are interested in doing is
working with groups that we can support through
design. One project that we have finished already was
119 for Human Rights in China (HRIC), a group that
was formed after the Tiananmen Square incident in
1989. They conduct research and publish reports on
human rights violations and also do advocacy work.
They came to us because they wanted a basic cleanup
of their logo.

HSU. My cousin works there, and she introduced us to
the executive director, Sharon Hom. HRIC had five
versions of their logo floating around, and none of
their printed materials visually enforced the fact that
they produce well-researched reports. Part of our task
was to give them a more cohesive and authoritative
look. The earlier issues of their *China Rights Forum*
magazine didn't look professional.

CHUNG. We created a typographic system that felt
more serious and more academic.

HSU. Then we held a few tutorials to train one of their
staff members so they could continue to use our tem-
plate independently of us.

There are other groups we've tried to do work
for. We contacted a nonprofit organization based in
New York whose programs benefit children and
teenagers. It was a program geared toward young
women that drew our interest and inspired us to
initiate contact with them, in the hope of donating a
logo. But after we sent our first sketches, they never
called us back. We're still trying.

118

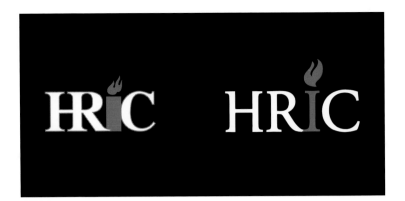

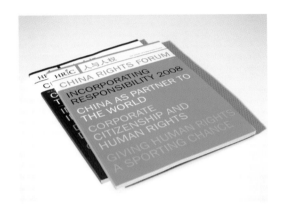

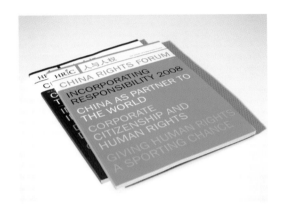

HRIC 人与人权
THE JOURNAL OF HUMAN RIGHTS IN CHINA

CHINA RIGHTS FORUM

WINTER 2003 $5.00

CORPORATE SOCIAL RESPONSIBILITY
CHINA AND INTERNATIONAL TRADE
BEIJING OLYMPICS 2008 AND HUMAN RIGHTS
ALSO: OTHER TOPICS

Another kind of work we're interested in is developing patterns. Basically a lot of these are designs without a function yet. They're wallpapers without a home.

KIDD. How do you go about creating these?

HSU. I sit down at the computer and start drawing. Often there's a narrative inspiration. One of my favorite patterns was drawn primarily during downtime while I was on a press check in a small town in Germany. I was reading a book about the murder of a nineteenth-century prostitute in New York, a woman who courted her clients with romantic letters and other theatrical aspects of these secret relationships. This book, the "fairy-tale" atmosphere of the German town I stayed in (whose architecture was for the most part spared during World War II) and a certain homesickness for New York, were the foundation for this particular pattern. Though I think no one would be able to tell...

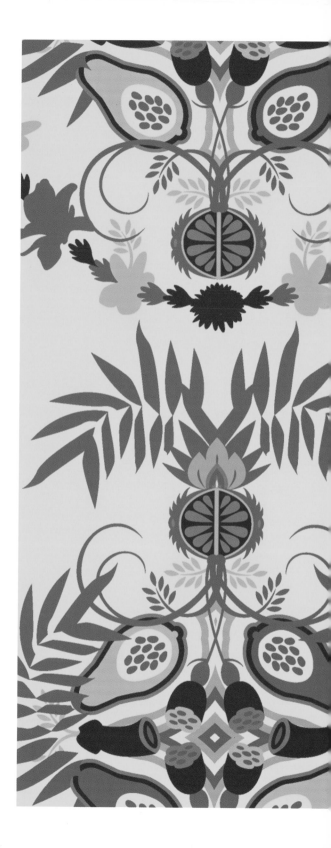

125
126
Another project that we're slowly, slowly, slowly trying to develop is an animal alphabet book. So far there's only A through I, but it's essentially a children's book with a different animal for every letter. And it's supposed to be cute.

KIDD. Supposed to be?

[*Laugher*]

If it were any cuter, I'd faint.

[*Laugher*]

What are you going to do for X?

HSU. There is an animal, but I've forgotten what it's called.

KIDD. Okay, just so you've thought about that.

[*Laugher*]

HSU. I actually have all the animals mapped; it's just drawing them and coming up with other words and drawing those that takes time.

I would be so happy if we could simply continue working with interesting people and maintaining access to an entertaining variety of projects. We're testing out greater geographical flexibility, which is particularly nice for me because so much of my family is out west.

CHUNG. We will always feel inspired by our work and collaborations. Sometimes the steps we need to take can be daunting, but I think both Karen and I are looking to that kind of challenge—it's what keeps the work interesting.

[*Applause*]

125

Bb
Bear

Cc
Cat

Dd
Dog

Ee
Elephant

Ff
Frog

Gg
Goat

Hh
Horse

Ii
Iguana

PROJECT CREDITS:

15 top left: *A Cool Million and The Dream Life of Balso Snell*, Nathanael West; book jacket, 1996; designer: Rodrigo Corral; illustrator: Ellen Ruskin; art director: Michael Ian Kaye; publisher: Noonday

15 top right: *The Death of Satan. How Americans Have Lost the Sense of Evil*, Andrew Delbanco; book jacket, 1996; designer: Rodrigo Corral; illustrator: Donna Mehalko; art director: Michael Ian Kaye; publisher: Noonday

15 bottom: *Hunger*, Knut Hamsun; book jacket, 1998; designer: Rodrigo Corral; illustrator: Donna Mehalko; art director: Susan Mitchell; publisher: Noonday

17 left: *The Life of Insects*, Victor Pelevin; jacket sketch, 1995; designer: Rodrigo Corral; art director: Susan Mitchell; publisher: FSG

17 right: *The Life of Insects*, Victor Pelevin; book jacket, 1995; designer: Rodrigo Corral; photographer: Frederick S. Schmitt; art director: Susan Mitchell; publisher: FSG

19 top left: *Mysticism for Beginners*, Adam Zagajewski; book jacket, 1997; designer: Rodrigo Corral; photographer: Frederick S. Schmitt; art director: Susan Mitchell; publisher: FSG

19 top right: *On the Rez*, Ian Frazier; book jacket, 2000; designer: Rodrigo Corral; photographer: Ian Frazier; art director: Susan Mitchell; publisher: FSG

19 bottom left: *Paris Trance*, Geoff Dyer; book jacket, 1998; designer: Rodrigo Corral; photographer: Diane Vasil; art director: Susan Mitchell; publisher: FSG

19 bottom right: *Survivor*, Chuck Palahniuk; book jacket, 1999; designer and photographer: Rodrigo Corral; art director: Timothy Hsu; publisher: W. W. Norton

21 top: Paperback catalogue for Grove/Atlantic, 2000; illustrator and art director: Rodrigo Corral

21 bottom: Hardcover catalogue for Grove/Atlantic, 2000; illustrator and art director: Rodrigo Corral

23 top left: "Recovering Japan's Wartime Past—and Ours," *The New York Times*, Op-Ed, September 4, 2001; designer: Rodrigo Corral; photographer: New York Times; art director: Peter Buchanan-Smith

23 top right: "Classes of Last Resort," *The New York Times*, Op-Ed, August 19, 2004; designer and photographer: Rodrigo Corral; art director: Brian Rea

23 bottom left: "The Watchdog, Now Grown Rabid," *The New York Times*, Op-Ed, August 22, 1999; designer and illustrator: Rodrigo Corral; art director: Christoph Niemann

23 bottom left: "Where Journalists Still Get Respect," *The New York Times*, Op-Ed, July 21, 1998; designer and photographer: Rodrigo Corral; art director: Nicholas Blechman

24: Mothers Against Drunk Driving (MADD); identity, business card, 1998; designer: Alan Dye

25: Spot illustrations, 2003; illustrator: Alan Dye; publisher: *The Royal Magazine*

26: Yoo-hoo; special-edition packaging, 2000; designer: Alan Dye, Landor; creative director: Jeremy Dawkins, Landor

27: Molson Canadian; packaging, 2000; design: Alan Dye, Landor; creative director: Richard Brandt

28: BIG (Brand Integration Group, Ogilvy); logotype, 2001; designer: Alan Dye, BIG; executive creative director: Brian Collins, BIG

29–31: Motorola; identity system and retail graphics, 2002; designers: Alan Dye, Bill Darling, Soohyen Park, BIG; creative director: Michael Ian Kaye, BIG; executive creative director: Brian Collins, BIG

32–33: Miller Brewing Company; corporate identity, historic mood boards, and wildpostings, 2003; designers: Alan Dye, Bill Darling, BIG; creative director: Michael Ian Kaye, BIG; executive creative director: Brian Collins, BIG; typography: James Montalbano

34–35: Miller Brewing Company; High Life packaging, 2003; designers: Alan Dye, Bill Darling, BIG; creative director: Michael Ian Kaye, BIG; executive creative director: Brian Collins, BIG

36: ADFED Columbus speech poster, poster for brand mythology speech, 2003; designers: Alan Dye, Bill Darling, BIG; executive creative director: Brian Collins, BIG

37: Push conference poster, 2001; design and illustration: Alan Dye

38–39: Balmori Associates; corporate identity, 2004; design: Alan Dye

41: Quest for Volume: The Origin of the Electric Guitar; museum kiosk, 2000; art director: Agnieszka Gasparska, Funny Garbage; programming: Colin Holgate, Funny Garbage; courtesy of the Experience Music Project

43: Quest for Volume: A History of the Acoustic Guitar; museum kiosk, 2000; art director: Agnieszka Gasparska, Funny Garbage; programming: Colin Holgate, Funny Garbage; courtesy of the Experience Music Project

44–45: Bloomberg; website, 2002; creative director: Raquel Tudela; art director: Agnieszka Gasparska, Funny Garbage; courtesy of Bloomberg

46: Bloomberg; broadcast screen, 2003; creative director: Raquel Tudela; art director: Agnieszka Gasparska, Funny Garbage; courtesy of Bloomberg

47: Bloomberg; corporate website, 2003; creative director: Raquel Tudela; art director: Agnieszka Gasparska, Funny Garbage; courtesy of Bloomberg

48–49: Fischerspooner; website, 2002; art director: Agnieszka Gasparska; illustrator: Rick Farr; courtesy of Fischerspooner and Capitol Records

51: David Mason; identity and website, 2003; art director: Agnieszka Gasparska

52–53: *Super Vision. A New View of Nature*, Ivan Amato; chart insert, 2003; chart design: Agnieszka Gasparska; creative director: Michael Walsh; book designer: Helene Silverman; publisher: Henry N. Abrams

54: Alice Chung and Karen Hsu working next to each other at 2x4, Inc.; illustration: Karen Hsu, Omnivore.

55 top left: *ANY 19/20*; open cover of double issue, 1997; editor: Cynthia Davidson; designers: Alice Chung, Michael Rock, 2x4; publisher: Architecture New York (ANY)

55 top right, middle, and bottom: *ANY 19/20*; interior spreads, 1997; editor: Cynthia Davidson; designers: Alice Chung, Michael Rock, 2x4; publisher: Architecture New York (ANY)

56: *Anything*; interior spreads, 2000; editor: Cynthia Davidson; designers: Katie Andresen, Alice Chung, Michael Rock, 2x4; publisher: Architecture New York (ANY)

57 top: *ANY 27*; folded and unfolded front cover, 2000; editor: Cynthia Davidson; designers: Katie Andresen, Alice Chung, Michael Rock, 2x4; illustration: Karen Hsu, 2x4; publisher: Architecture New York (ANY)

57 middle: *ANY 27*; interior spreads, 2000; editor: Cynthia Davidson; designers: Katie Andresen, Alice Chung, Michael Rock, 2x4; publisher: Architecture New York (ANY)

57 bottom: *Anything*; front and inside cover, 2000; editor: Cynthia Davidson; designers: Katie Andresen, Alice Chung, Michael Rock, 2x4; publisher: Architecture New York (ANY)

59: Prada; wallpaper, scale and density studies, 2001; designers: Karen Hsu, Michael Rock, and others, 2x4; original floral pattern: Karen Hsu; photography: 2x4, OMA/AMO, and others; architects: Rem Koolhaas, Ole Scheeren, Eric Chang, Tim Archambault, OMA/AMO; producer: Sharon Ullman

60–61, 63 top: Prada; wallpapers, explorations, 2001; designers: Karen Hsu, Michael Rock, and others, 2x4; original floral pattern: Karen Hsu; photography: 2x4, OMA/AMO, and others; architects: Rem Koolhaas, Ole Scheeren, Eric Chang, Tim Archambault, OMA/AMO; producer: Sharon Ullman

63 bottom: Prada; wallpaper, illustration of final installation, 2001; designers: Karen Hsu, Michael Rock, and others, 2x4; original floral pattern: Karen Hsu; photography: 2x4, OMA/AMO, and others; architects: Rem Koolhaas, Ole Scheeren, Eric Chang, Tim Archambault, OMA/AMO; producer: Sharon Ullman; illustration: Karen Hsu, Omnivore

65 left: *Edgewater Angels*, Sandro Meallet; book jacket, 2000; art director: Rodrigo Corral; photographer: Jana Leon/Graphistock; publisher: Doubleday

65 right: *John Henry Days*, Colson Whitehead; book jacket, 2001; art director: Rodrigo Corral; photographer: Brown Brothers; publisher: Doubleday

67: *Choke*, Chuck Palahniuk; book jacket, 2001; art director: Rodrigo Corral; illustrator: Bob Larkin; publisher: Doubleday

68: *Lullaby*, Chuck Palahniuk; jacket sketch, 2002; designer: Rodrigo Corral; illustrator: Andrew Davidson; creative director: John Fontana; publisher: Doubleday

69 top: *Lullaby*, Chuck Palahniuk; jacket sketch, 2002; designer: Rodrigo Corral; illustrator: Joel Holland; creative director: John Fontana; publisher: Doubleday

69 bottom: *Lullaby*, Chuck Palahniuk; book jacket, 2002; designer: Rodrigo Corral; illustrator: Judy Lanfredi; creative director: John Fontana; publisher: Doubleday

70–71: *Invisible Monsters*, Chuck Palahniuk; book jacket, 1999; designer: Rodrigo Corral; illustrator: Gene Mollica; art director: Ingsu Liu; publisher: W. W. Norton

72: *Stranger than Fiction*, Chuck Palahniuk; book jacket, 2004; designer: Rodrigo Corral; photographer: Michael Schmelling; creative director: John Fontana; publisher: Doubleday

73: *Diary*, Chuck Palahniuk; book jacket, 2003; designer: Rodrigo Corral; hand lettering: Leanne Shapton; creative director: John Fontana; publisher: Doubleday

75: *Fight Club*, Chuck Palahniuk; book jacket, 2004; designer: Rodrigo Corral; photographer: Michael Schmelling; creative director: Raquel Jaramillo; publisher: Owl Books

77–78: NYC 2012; identity system, 2003; designer and illustrator: Alan Dye, BIG; executive creative director: Brian Collins, BIG

79: Times Square; identity, 2003; designer: Alan Dye, BIG; typography: Bill Darling, BIG; executive creative director: Brian Collins, BIG

81: Kate Spade; various graphics, 2004; designer: Alan Dye

83: Kate Spade; 2005 agenda, 2004; design: Cheree Berry; design director: Alan Dye; photographer: Studio ZS

84–85: Kate Spade; fall ad campaign, 2004; design director: Alan Dye, creative director: Andy Spade; photographer: Christopher Griffiths; stylist: Jeffrey Miller; fashion stylist: Grace Cobb

86: Jack Spade; fall 2004 look book, 2004; designer: Gillian Schwartz; design director: Alan Dye; writer: Ben Greenman

87 top: *PAPER* magazine, 20th anniversary advertisement, 2003; designers: Abby Low, Alan Dye

87 bottom: *The Bird*, 2003; designer: Gillian Schwartz; photographers: the dum-dum showers; publisher: Jack Spade Press,

88: Kate Spade; Maira Kalman baby blocks, 2004; illustrator: Maira Kalman; designer: Alan Dye

89: Kate Spade; Maira Kalman dog collars, 2004; illustrator: Maira Kalman; designer: Alan Dye

91: Trunk Ltd; website, 2003; creative director: Brad Beckerman; art director: Agnieszka Gasparska; flash programming: Yi Liu; courtesy of Trunk Ltd.

92–93: Panoptic; website, 2004; art director: Agnieszka Gasparska; flash programming: Yi Liu; courtesy of Panoptic

95: The Cooper Union; interactive view book CD-ROM, 2002; art director: Agnieszka Gasparska; flash programming: Yi Liu; sound design: Kevin Scott; courtesy of the Cooper Union

96: Alice Chung and Karen Hsu working as Omnivore in New York City; illustration: Karen Hsu, Omnivore

97–99: Whitney Biennial 2004; box and catalogue set, 2004; curators: Debra Singer, Shamin M. Momin, Chrissie Iles; biennial coordinator: Meg Calvert-Cason; head of publications and new media: Rachel de W. Wixom; catalogue design: Alice Chung and Karen Hsu, Omnivore; printing and color separations: Steidl, Göttingen, Germany; binding: Lachenmaier, Reutlingen, Germany; produced by the Publications and New Media Department at the Whitney Museum of American Art, New York; photos by Tamara Staples

101: *Studioworks* 10: Harvard University Graduate School of Design 2001–2003; book of student work, 2004; designers: Alice Chung and Karen Hsu, Omnivore; printing and binding: Oddi, Reykjavik, Iceland; produced by the Publications Department, Harvard Graduate School of Design; photos by Tamara Staples

102: Private residence rooftop mural; painted rooftop in Avalon, New Jersey, 2003; design: Alice Chung and Karen Hsu, Omnivore; original Princeton University tiger illustration: Robert Venturi

103 top: Private residence rooftop mural; explorations, 2003; design: Alice Chung and Karen Hsu, Omnivore

104 bottom: Private residence rooftop mural; final illustration, 2003; design: Alice Chung and Karen Hsu, Omnivore; original Princeton University tiger illustration: Robert Venturi.

104: Target Inn; view from Asian garden room to Sean Conway formal garden room, 2004; design: Alice Chung and Karen Hsu (Omnivore) and David Stark for Avi Adler, Brooklyn, New York; photo by Mick Hales

105 top: Target Inn; view from dining room to living room, 2004; design: Alice Chung and Karen Hsu (Omnivore) and David Stark for Avi Adler, Brooklyn, New York; photo by Mick Hales

105 bottom: Target Inn; bathroom, 2004; design: Alice Chung and Karen Hsu (Omnivore) and David Stark for Avi Adler, Brooklyn, New York; photo by Mick Hales

106: Target Inn; detail of backyard barbecue room, 2004; design: Alice Chung and Karen Hsu (Omnivore) and David Stark for Avi Adler, Brooklyn, New York; photo by David Jacobson

107 top: Target Inn; detail of ceiling and hall, 2004; design: Alice Chung and Karen Hsu (Omnivore) and David Stark for Avi Adler, Brooklyn, New York; photo by David Jacobson

107 bottom left: Target Inn; bedroom, 2004; design: Alice Chung and Karen Hsu (Omnivore) and David Stark forAvi Adler, Brooklyn, New York; photo by Mick Hales

107 bottom right: Target Inn; view from downstairs hall to David Kirk Garden Room, 2004; design: Alice Chung and Karen Hsu (Omnivore) and David Stark for Avi Adler, Brooklyn, New York; photo by Mick Hales

109: Creative Time Burlesque Bash; benefit invitation materials, 2004; design: Alice Chung and Karen Hsu, Omnivore; printing: Masterpiece Printers, New York; produced by Creative Time; photos by Tamara Staples

111: Bar Mitzvah invitations; invitation components, 2004; design: Alice Chung and Karen Hsu (Omnivore) and David Stark for Avi Adler, Brooklyn, New York; printing: Masterpiece Printers, New York; photos by Tamara Staples

112–113: Fox River Paper Co.; Fox River Forever Green paper sample promotional, 2004; designer: Rodrigo Corral; photographer (teacups): Tamara Staples; illustrator (tires): Jeffrey Middleton; photographer (chairs): courtesy of Herman Miller Inc.

114: *Bush on the Couch*, Justin A. Frank, M.D.; book jacket, 2004; designer: Rodrigo Corral; photography: Corbis; art director: Michelle Ishay; publisher: Regan Books

115 top: *A Million Little Pieces*, James Frey; book jacket, 2003; designer: Rodrigo Corral; photographer:

Fredrik Broden; creative director: John Fontana;
publisher: Nan A. Talese, Doubleday

115 bottom: *The Triumph of Love Over Experience*, Wendy
Swallow; jacket sketch, 2002; designer and
photographer; Rodrigo Corral; art director:
Allison Warner; publisher: Hyperion

117 top left: *Jamesland*, Michelle Huneven; paperback
jacket, 2004; designer: Rodrigo Corral;
photographer: Tamara Staples; art director: John
Gall; publisher: Vintage

117 top right: *A Defense of Ardor*, Adam Zagajewski; book
jacket, 2004; designer: Rodrigo Corral;
photographer: Gus Powell; art director: Susan
Mitchell; publisher: FSG

117 bottom left: *The Meaning of Sports*, Michael
Mandelbaum; jacket sketch, 2004; designer;
Rodrigo Corral; photographer: Jelly Bean; art
director: Nina Damario: publisher: Public Affairs

117 bottom right: *Translation Nation*, Héctor Tobar; book
jacket, 2004; designer: Rodrigo Corral; illustrator:
Judy Lanfredi; hand lettering: James O'Brien; art
director: Lisa Amoroso; publisher: Riverhead

118–119: Kate and Jack Spade; details of office mood
boards, 2004; designer: Alan Dye

120–121: Kate Spade and Alexander Girard; various
products, 2004; designer and design director: Alan
Dye, all original art courtesy of Alexander Girard

121 top: Office, Agnieszka Gasparska

123 bottom: Crafty designs, 2003–2004; Agnieszka
Gasparska

124: Hot Mama Italian Pizza Bread; packaging design,
2004; creative director: Jeremiah Coyle; design:
Agnieszka Gasparska; courtesy of Hot Mama
Foods

125: Team Rad; website title cards, 2004; design:
Agnieszka Gasparska and Matthew Bowne;
courtesy of Team Rad

126: Alice Chung and Karen Hsu working as Omnivore
from any location; illustration: Karen Hsu,
Omnivore

127 top: Human Rights in China; original logo (left) and
logo refinement (right), 2003; design: Alice
Chung and Karen Hsu, Omnivore

127 bottom: Human Rights in China; China Rights
Forum redesign, 2003; design: Alice Chung and
Karen Hsu, Omnivore; publisher: Human Rights
in China

128–131: Patterns, 2002–2004; illustration: Karen Hsu,
Omnivore

132–133: Animal Alphabet; A–I, 2004; illustration: Karen
Hsu, Omnivore